NESE
MODERN

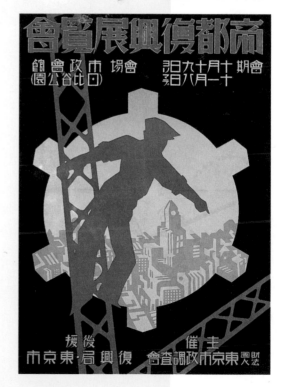

GRAPHIC DESIGN
BETWEEN THE WARS

JAPANESE MODERN

JAMES FRASER

STEVEN HELLER

SEYMOUR CHWAST

CHRONICLE BOOKS SAN FRANCISCO

ACKNOWLEDGMENTS

Thanks to our editor Bill LeBlond, art director Michael Carabetta, and associate editor Leslie Jonath at Chronicle Books.

This book would not have been possible had it not been for the cooperation and generosity of several key people including Shima Tayo (Tokyo) who dealt with organizational details, Kawahata Naomichi (Tokyo) who generously loaned materials from his collection as well as continual advice, and Bando Yumiko for efficient fact checking. Thanks also to Mizuno Hiroko, Yumiko Takasue Aleshnick, Jennifer Wu, Ursula Sommer, Sibylle Fraser, Caitlin James, Eleanor Friedl, Osaka Eriko, Nakamura Keiko, Horikiri Yasuro, Saji Yasuo, and Kobayashi Masaru for photographic services, Roxanne Slimak here at The Pushpin Group for design, and Adie Lee for production assistance.

TEXT BY
James Fraser

EDITED BY
Steven Heller

ART DIRECTION
Seymour Chwast

DESIGN
Roxanne Slimak

Library of Congress Cataloging-in-Publication Data available.

Printed in Hong Kong.
ISBN 0-8118-0509-3.
Distributed in Canada by Raincoast Books,
8680 Cambie Street, Vancouver, B.C. V6P 6M9
Chronicle Books, 275 Fifth Street, San Francisco, CA 94103
10 9 8 7 6 5 4 3 2 1

CONTENTS

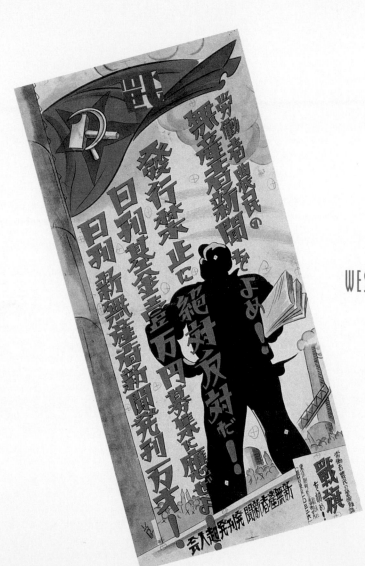

T his compilation provides a brief overview of a subject and period generally overlooked in Western writing on graphic design. Modernism in Japanese commercial design flowered in the brief period between World Wars I and II. Specifically, our concern is the time period following the Tokyo-destroying Kanto earthquake and fire of September 1923 through the beginning years of nationalism's rise in the 1930s.

Large segments of the population in the major urban centers of Japan had been readily embracing much that was Western and vanguard in literature, the fine and applied arts, and commercial practice from the closing years of the nineteenth century. So it is no surprise that the growing practice of "looking West" would continue and even accelerate as communication media kept pace with the populace and expanded the Western influence in the post–World War I period.

To cite just one example from the arts that characterizes the rapidity of this transmission process: F. Marinetti's first Futurist manifesto was published in February 1909 in *Figaro* (Paris). Within the same year, besides its publication in the periodical *Subaru* (*The Pleiades*), it was translated in Japan. Leaders of other European literary and art movements regularly found welcoming counterparts in Japan with just as great a readiness to see articles and documents translated and circulated.

A Mitsukoshi Department Store poster of 1925 designed by Sugiura Hisui.

Similarly, one can see in the illustrations herein something of the immediacy of the transmission process as well as that mysterious and often amusing appropriation and application of a visual idiom to a purpose quite different from the original intent. But the primary purpose of this compilation is to stir us to look beyond our Anglo-European graphic design history and perhaps even stimulate greater use of the comparative method in design historical studies.

A few words of acknowledgment: this project could not even have been undertaken without the assistance of Shima Tayo (Tokyo) and Kawahata Naomichi (Tokyo). Mrs. Shima dealt with vexing organizational details. Kawahata, a designer and collector, has also generously loaned materials from his collection as well as offering continual advice. Much fact checking has been done by Bando Yumiko. On-call translating and editorial assistance have been given by Mizuno Hiroko, Yumiko Takasue Aleshnick, Jennifer Wu, and Ursula Sommer. Sibylle Fraser and Caitlin James have, as always, dealt with administrative details. Eleanor Friedl has managed various phases of the manuscript production. Although the individuals and institutions that have given permission for use of many of the illustrations are duly credited, we wish to thank them collectively for their generosity and Osaka Eriko for dealing with many rights and permissions details. Nakamura Keiko of the Yayoi Museum deserves, as well, a special thank you for her efforts. Photographic services have been provided by Horikiri Yasuro, Saji Yasuo, and Kobayashi Masaru.

There are few excuses for error, but an explanation is in order for those errors of fact (such as in dates, sizes, or designer identifications) that may have occurred. (Errors of interpretation rest with this writer.) Some posters could not be examined. Others lacked supporting documentation but approximate dating was possible from internal evidence. In some instances it has been necessary to rely on others for dating, and there is disagreement among Japanese scholars on a number of items. The dates for such items are followed by question marks.

The larger problems for those undertaking research in Japanese commercial graphic design history of the Modernist period are the fragmentary nature of research collections, the lack of substantial surviving designer archives, and the absence of biographical compendia of the graphic designers working from the Meiji era (1868–1912) to the close of World War II. Current efforts to reconstruct Japan's commercial graphic history are hindered by the destruction of the major design center, Tokyo, twice in this century.

Throughout this book we have used the Japanese form for names: family name precedes given name, except in bibliographical citations where the language of the text is Western and the citation conforms to Western style. Dates are given only for Japanese designers who are under discussion—at first mention and in the name index—or whose work is illustrated. In a number of instances it was not possible to establish dates from the resources available.

The works consulted, which are cited throughout and in the appendices, taken together are among the handful of basic works for a study of Japanese graphic design history of the period. Unfortunately, there is no definitive work available in English or Japanese specifically concerned with design during this period. Even Japanese exhibitions on this period and the accompanying catalogs are a relatively recent occurrence—primarily since the early 1980s.

JAPANESE COMMERCIAL GRAPHIC DESIGN AND
THE SETTING OF THE STAGE FOR MODERNISM

T he traditional design standard of Japan has been maintained by successive generations of graphic and industrial designers since the opening of Japan. Design arbiters within the larger culture have traditionally held to an immediately recognizable, if not precisely defined, design aesthetic. Yet there also has existed, from the beginning of the Meiji era (1868–1912) through the interwar period of Japanese Modern style and continuing even to this day, a random advertising jumble of design idioms of

A typical late-1890s
broadside/poster,
advertising a textile shop.

9

the West with those of the traditional East. The first two examples shown in this section, from the late nineteenth century, give some hint of this "design without designers." Aside from being typical of that era when graphic design was left largely to the whims of the printer and his clients, this type of illustration has its counterpart in any number of cultures. But in Japan another factor should be considered in the question of whether and how a culture adopts new design elements. Satō Kōichi gives a brief, helpful explanation: "Traditionally and without exception, what is valued is that which has come over the ocean. This is understandable, for throughout the centuries of Japanese history, that which was new always came by way of the sea."[1]

Modernist ideas came thick and fast in ships (and planes) from the West in the first four decades of this century. Some designers were successful in assimilating and transforming Western design concepts and style that were perceived as being modern. Other designers appropriated Western styles badly, without apology and without much attempt at transformation. It was clear by the close of the first two decades that a metamorphosis was taking place in both the fine and applied arts. The amalgam of design that appeared in the first two decades of the century was revolutionary.

The few, select illustrations compiled here demonstrate the phenomenon that some Japanese graphic design historians refer to as Japanese Modern. Including the good along with the marginal, this compilation tests our underlying contention that graphic design in Japan from the early years of the century to the period of World War II was sensitive, in varying degrees, to changes taking place throughout the world.

The majority of the examples that illustrate the absorption and transformation of Modernist images from the West are posters. Japan took the poster seriously as an advertising medium (with attendant interest on the part of cultural institutions) from the beginning of the twentieth century. The collection of the Kyoto University Museum of Industrial Arts and Textile Fibers is founded upon its acquisition of a collection spanning the period 1890 to 1897, and acquisitions continue unabated today.[2] Also presented here are periodical covers, matchbox covers, trademarks, and other design forms that introduced Western graphic styles to shopkeepers and beginning designers in the late 1920s and early 1930s. A brief typographic proposal for would-be Modernist designers is included as well.

But just what is Japanese Modern? If one asks any number of Japanese graphic artists, regardless of generation, the answer usually implies a value derived from a blend of Russian Constructivism, French Art Deco, Bauhaus, and for lack of a better phrase, Proletarian Graphic. There are other elements as well. The *shinkō-shashin* or New Photography, identified with many photographers of Osaka, Tokyo, and Nagoya in the late 1920s to mid-1930s, incorporated much that could fit the description Japanese Modern. Because of its diverse elements, there is no single, readily identifiable Japanese Modern style such as with Jugendstil or French Art Deco.

Richard Thornton, in *The Graphic Spirit of Japan*,[3] gives a tantalizing overview of the entire scope of Japanese graphic design. Though he begins before the Meiji era and continues with somewhat abrupt, decade-delimited units to the 1980s, Thornton would likely be the first to maintain that Japanese graphic design history cannot be quite so decade-confined—particularly the 1920s and 1930s. A decided influence from the Western modern movements beginning in the late nineteenth century spilled over into the twentieth, inspiring Japanese designers in the 1920s.

In the years from the mid-1920s until the onset of mobilization for war in the mid-1930s, a few Japanese graphic designers provided the theoretical frame for what was to develop in the post–World War II period. Three of the surviving designers who provided continuity for the concept of art direction are Imatake Shichirō (b. 1905), Kōno Takashi (b. 1906), and Kamekura Yūsaku (b. 1915). Each has worked actively into the 1990s. Preeminent among their inter-war-period colleagues were Ōta Hideshige (1892–1982), Yamana Ayao (1897–1980), Hara Hiromu (1903–86), and Natori Yōnosuke (1910–62). Each had a founding role in the direction of graphic art in Japan.

By the time the Meiji era came to a close in 1912 with the death of the Emperor Meiji, forerunners of modern design were already being noticed. In 1907 Hashiguchi Goyō (1880–1921) created his poster with a stylized *kimono* model for the Mitsukoshi Department Store. Sugiura Hisui (1876–1965) fol-lowed with an even more stylized kimono poster for the same client in 1914.

Japanese artists, at first mainly painters, had been drawn to Western capitals since the late 1880s.[4] Graphic artists, architects, and photographers traveled as well, beginning shortly after the turn of the century, and returned with artwork, books, posters, periodicals, and consumer goods acquired in Berlin, Paris, London, and New York, among other cities. At least four young architects were in thrall to Frank Lloyd Wright, who since the turn of the century had seen in traditional Japanese aesthetic principles the answer to his own architectural longings. In subsequent decades Bauhaus architects came to Japan and young Japanese went to Europe, if not to study at the Bauhaus at least to meet with Bauhaus students. In considering the following list of some events in Modernism's beginnings, note that the publication date of F. Marinetti's "Manifeste Futuriste" in *Suburu* (1909) gives one some sense of the rush with which change occured.

Mitsukoshi Department Store establishes its design department in 1909 □ Ishii Hakutei's article introducing Cubism to Japan is published in Asahi, October 1911 □ Yorozu Tetsugorō (1887–1927) paints "Ratai bijin" (Nude-beauty), with its influence of German Expressionism, Fauvism, and Cubist elements—a daring painting in 1912 □ The periodical *Gendai no yōga* (*Contemporary Western Painting*) publishes its first issue, May 1912 □ Mitsukoshi Department Store opens its one-minute

photo service, 1912 □ Takashima-ya Department Store establishes its design department, 1913 □ *Uindō Gahō* (*Illustrated News of the Show Window*) begins publication, Tokyo, March 1914 □ Exhibition of German Expressionist woodcuts from Der Sturm Gallery (Berlin) opens at Hibiya Gallery, Tokyo, April 1914 □ Society for the Study of Advertisements launched at Waseda University, 1914 □ Morinaga Confectioncry, a pioneer in Western-style candy manufacturing, opens its teaching-oriented design department, 1915 □ Shiseido Cosmetic Company establishes its design department, 1916 □ Frank Lloyd Wright starts work on the design of the Imperial Hotel, Tokyo, January 1917 □ David Burliuk comes to Tokyo and the first exhibition of Russian avant-garde painting opens, October 1920 □ Shashin Geijutsu-sha (Society for Art Photography) is established, and the first issue of *Shashin Geijutsu* appears, June 1921 □ Exhibition of Ossip Zadkine's sculpture opens at Bunkagakuin, Tokyo, April 1922 □ Murayama Tomoyoshi's first MAVO exhibition opens in Tokyo, July 1923 □ Murayama Tomoyoshi publishes his *Gendai no geijutsu to mirai no geijutsu* (*Art Present and Future*), November 1924.

This listing only touches on the flurry of cultural activity then gaining momentum in Japan. The bookstore's role in the dissemination process has yet to be documented in the rise of Modernism in Japan, but we know from memoirs of intellectuals living in that period that it was substantial and vital throughout the country. In the mid- and late 1920s,

A late-1890s broadside/poster promoting a rice shop.

booksellers such as Kaiser (a small German bookstore in Kanda district), Sanseido (a major bookstore/publisher also in Kanda), Fukumoto-Shoin (in Hōngo district on the Kanda side), and Meiji-Shobō (in

cations; and vanguard art exhibition catalogs. Similarly, avant-garde Soviet books and periodicals (along with literary and political works) began to appear in some of the same shops. In 1931, Soviet architectural journals, art periodicals such as *Proletarskoe Iskusstvo*, and the new *USSR in Construction* were available at Nauka-sha, the agent for Russian publications in Tokyo throughout the 1930s.[5] To be sure, the venerable Maruzen Bookstore in Nihonbashi for decades had had a department of imported books, and in the 1930s this included works on Western graphic design trends.

One of the more important individuals in opening the way to increasingly Modernist ideas was the restless Murayama Tomoyoshi (1901–77). Murayama began in 1920 contributing illustrations to the children's magazine *Kodomo no Tomo* and continued contributing sophisticated illustrations for children's magazines for a number of years.[6] But Murayama is known primarily for his erratic but hard-to-ignore careers first as a promoter of German expressionist art, next as a painter in an expressionist style, and then as a dadaist architectural creator, followed by yet other experimentation. In 1922 Murayama left for Berlin to study primitive Christianity at what is now Humboldt University. He dropped out because of language deficiencies (Latin) and began circulating in the avant-garde art community. He met the aspiring artists Wadachi Tomoo (1900–25) and Nagano Yoshimitsu (1902–68), and together they formed the "Japanese

Kanda) all carried an international stock, as did dealers in Osaka, Kobe, and other cities. Included in the stock were German graphic design periodicals such as *Gebrauchsgraphik*; Western photography annuals from Berlin, New York, Paris, and Prague; Bauhaus publi-

Futurist Artists in Berlin." With Nagano, Murayama even exhibited in the March 1922 Futurist exhibition at J. B. Neumann's Gallery, where he met Marinetti. Murayama also met Kandinsky in Berlin and later corresponded with him. Just prior to leaving Berlin at the close of 1922, he mounted an exhibition of his own work at the bookshop and gallery on the Potsdamer-Strasse number 12 operated by Käte and Emma Twardy.[7] Following his return in January 1923, he mounted the turning-point exhibition "Works in Conscious Constructivism,"[8] which arguably was instrumental in the various experimentations in constructivist design elements observable in the work of a number of young commercial designers that continued until the early 1930s. Malik Verlag portfolios illustrated by George Grosz were also brought back by Murayama, and these in turn had an influence most visible in the work of Yanase Masamu (1900–45), who produced his Grosz-like *Ecce Homo* drawing in 1925. In June of 1923 Murayama launched his MAVO group along with Yanase and other artists of the growing avant-garde. The theatrical performances, the exhibitions of their work, the posters announcing their events, and their set designs were hard to avoid in the pre-earthquake spring of that year. September's earthquake destroyed Tokyo but not the MAVO group. July of 1924 saw the publication of the first issue of the MAVO group's graphically clumsy periodical also titled *MAVO*. By the time the periodical ceased publication in the following year with its seventh issue, the MAVO group had become a force in the modernization of graphic

Cover of an issue of the vanguard art periodical *Mavo* (number 5, 1925) founded by Murayama Tomoyoshi.

design in Japan. MAVO featured hard-driving use of photomontage, typography, and designs influenced by a number of the European art "isms" of the time. But of major importance for the introduction of Modernist ideas was the publication in translation of articles by Kurt Schwitters, El Lissitzky, and others. Lissitzky and Hans Arp's documentary work on constructivism, merz, futurism, etc., *Die Kunstismen* (Erlenbach-Zürich: Eugen Rentsch Vlg., 1925), was

introduced to Japan in *Koseiha Kenkyu* (*Study on Constructivists*), published by Chūō Bijutsu-sha in 1926. Yanase, Murayama's comrade in the MAVO cause and fellow graphic designer, was also a difficult-to-ignore force in this time regardless of whether, like Murayama, he was designing heavy-handed posters for left-wing political causes or vanguard theatre or was illustrating children's books and periodicals.

The spirit of Modernism in all this cultural tumult continued to gain momentum despite the devastating Tokyo earthquake and fire. Art exhibitions ranged from the Russian modernist exhibition of October 1920, with its entourage of artists including the "father of Russian futurism," David Burliuk, to the traveling "Foto und Film Ausstellung" of 1929, which arrived in a reduced version from Germany and opened in Tokyo in April 1931, moving to Osaka in July. These exhibitions had a cumulative impact that can be discerned locally on an event-by-event basis. One need only lay out samples of local cultural-event advertising in the months following any exhibition to see the almost immediate transmission of design idioms or elements.

Art periodicals such as *Mizue* (1905–92)[9] and advertising design journals such as *Kōkoku-kai* (1926–41), as well as such numerous experimental and other kinds of periodicals launched in the 1920s as *Ge.Gingigam. PRRR.Gimgem* (1924–25), *Photo Times* (1924–41), and *Affiches* (1927–30), were all part of the forces at work indirectly and directly on the developing Japanese advertising and graphic design circles.

Not to be overlooked are the later periodicals, such as the architecture journal *Kenchiku Kigen* (October 1929 to March 1930: five issues), with its "Bauhaus" special issue of November 1929, and *Kōga* in 1932 and 1933, both major influences in the Modernist trend.

Avant-garde painting and poster exhibitions, regular lecturers from European art circles, and the monograph publishers Kinsei-dō, Bon-shoten, and Tenjin-sha, among others, with their translations of major European art and graphic design works, provided yet another level of influence. The Japanese Modern phenomenon is thus much more complex than a single, unified style. Representative works from the various styles-within-styles, or styles formulated according to political ideology, are exemplified throughout the following pages. Some categorization, designer-identification, and dating of works will be readily apparent. For example, the Esprit Nouveau has Sugiura as its leading proponent, and the Prolet-avant-garde has Murayama and Yanase as its leading figures. Identification of other work is speculative because physical evidence without data (sometimes only as recorded in a secondary source) is all that remains. Natural disaster, police raids during the early 1930s, war, and normal attrition all have played parts in the destruction of artists' archives and other primary sources.[10]

Some Japanese commentators on this period of transition—from the openness in the mid-1920s to narrow nationalism in the mid- to late 1930s—refer to the period from the mid-1930s to

the close of World War II as "The Dark Valley."
But despite the constraints imposed from various
quarters during that period, Western Modernist-
movement books and periodicals continued to be
available at the shops mentioned above and were
avidly read, according to diarists of the time.
Vanguard photo and painting exhibitions continued
to be held even as late as 1937. One such was the
June 1937 exhibition of Western surrealist painting
held in Tokyo. Nevertheless, artistic expression
and exhibition of art forms at odds with the regime's
goals inevitably succumbed to repression in Japan,
as it did in Germany in the same period.

DESIGNERS, CLIENTS, AND EARLY JAPANESE
MODERNISM: THE EXAMPLES OF MITSUKOSHI
AND SHISEIDO

To modify the saying by Calvin Coolidge: the busi-
ness of graphic design is usually business. No more
dramatic demonstration of this mutually beneficial
relationship can be seen than in Japan, once it became
"open for business" in 1868. The Mitsukoshi Department
Store was not the only Japanese department store in the
early twentieth century that followed European retailing
trends, but it was in the forefront both in using well-
known artists for promotional graphics and in training
graphic designers to advance product identification and
marketing. The present corporate logo, derived from the
crest of Echigo-ya, forerunner of Mitsukoshi, came late in
the store's history in 1904, when the company that had
been in continuous operation (but under various owners)
since 1673 began operating under the name The

Mitsukoshi Dry Goods Store Company Limited.

The business on which the store was established
was the retail sale of the kimono and its accessories.
Innovations in display, sales practices, and advertising,
to say nothing of store location, placed Mitsukoshi in
a leading and often imitated position for generations.
In 1907 the company paid the well-known artist
Okada Saburōsuke (1869–1939) for the rights to use
his Western-style "Portrait of a Lady" as a basis
for a poster promoting kimono. This created some-
thing of an advertising sensation. It launched the
genre of what is usually termed the "Bijin-ga poster,"
a type featuring a kimono-clad model with traditional
hair style and ornamental combs. Mitsukoshi also
led the way in representing Western hair styles in
the modified Bijin-ga poster. Chipping away even
further at tradition, poster models in general were
increasingly depicted with greater expression and
with lips parted. A minimum of text and a discreetly
placed company logo were invariable features of
such posters from the beginning of this style and
well into the transition away from tradition that was
broadly observable by the mid-1920s.

It was, however, the appointment of Sugiura
Hisui as an adviser to Mitsukoshi in 1908 and
its chief designer in 1910 that helped set in
motion the modern movement in advertising graphic
design. It was Sugiura who was to lead the way from
an Art Nouveau–derived style to a distinctive styliza-
tion, with a minimum of detail and a use of flat colors,
in the late teens and early 1920s. While there is support

for the view that Sugiura remained primarily an illustrator rather than a designer advocating an overall design concept, his style nonetheless remained for many an important phase in Modernist graphic design in posters, periodical covers, and matchbox covers. Sugiura created not only influential illustrations/designs for posters and ephemera but a number of covers for Mitsukoshi's publicity magazine, *Mitsukoshi*. It was called *Mitsukoshi Times* until 1911 and *Mitsukoshi* from then until its suspension in 1933. (Sugiura ceased working regularly for the company in 1934.)[11] Sugiura was also a member of the editorial committee of the most important design compendium of its time, *The Complete Commercial Artist*. Hamada Masuji (1892–1932), the founder/editor-in-chief of *Gendai Shōgyō Bijutsu Zenshū* (*The Complete Commercial Artist*), together with Watanabe Soshū (1890–1986), Nakada Sadanosuke (1888–1970), and Miyashita Takao (1890–1972), initiated this work in 1928 and completed it in twenty-four volumes in 1930.[12] The work assisted store owners, who were its chief purchasers, as well as influencing young graphic designers.

It was Sugiura's involvement with the poster as advertising medium that awakened other firms and poster makers to its potential. Although he was featured in Mitsukoshi's store gallery in an exhibition of his covers for its in-house periodical in 1912, and later in 1914 in an exhibition of poster masterpieces, it was not until the next decade and after his trip to France that he organized the Shichinin-sha. This was an association with the express purpose of research into

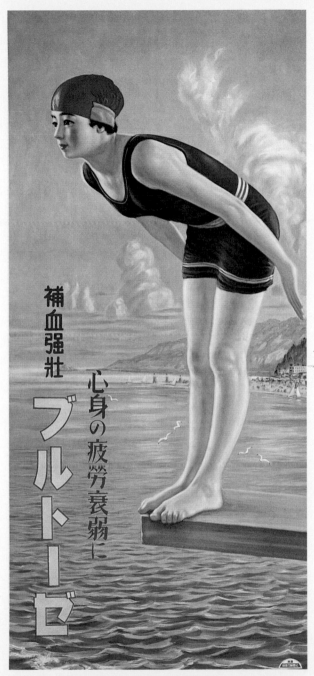

"Blutose tonic helps eliminate mental and physical fatigue." An early-1930s patent medicine poster. Designer unknown.

the effectiveness of color, style, and typography in poster design. Exhibitions were part of the Shichinin-sha mission. His founding of the periodical *Affiches* furthered his poster-as-medium concerns as well as having a part in the development of graphic design journalism in Japan. While the journal's existence was brief (fourteen issues were published between July 1927 and late 1930), it served as a means for introducing European and North American poster design to Japanese designers as well as providing a medium for exhibiting the work of Japanese poster makers.

Although Sugiura is identified closely with Mitsukoshi, he was frequently commissioned to do posters for other clients. Some of the better known were the Tokyo Subway Company (1927), South Manchurian Railway (1927), JOAK Radio Company, Stone Coat Paints, the Japan Tourist Bureau, Tomoe Soap, and the Minori Cigarette Company (1930), as well as Shichinin-sha's own annual poster show (1926–28).

The extent of Sugiura's contribution to Japanese graphic design in the twenty-five-year period of his association with Mitsukoshi remains much more than that of an exemplary designer. His students and those younger artists whom he influenced directly and indirectly are his legacy. His publishing and exhibition ventures served a catalytic purpose beyond their initial effect as media of information.[13]

By coincidence, the predecessor of the Mitsukoshi Department Store had carried cosmetic products of a modest-sized Tokyo pharmacy that had opened in Ginza in 1872. This pharmacy's direct successor, Shiseido Company Limited, recognized early in its history that successful marketing of cosmetics was basically the selling of illusion through the creation of an image. The first two-and-a-half decades of Shiseido's existence had no Sugiura Hisui to transform and coordinate its own development of a graphic image. But it did have a succession of designers attuned to what Mitsukoshi and other merchants were doing; and recognizing the development around them, Shiseido designers also created effective designs.

In 1928 the relatively young Yamana Ayao was invited to join the Shiseido Company as a designer. His tenure was brief but far reaching in influence. Since 1917 Yamana had worked, among other positions, as an illustrator and a publisher of a short-lived periodical, *Chocolate*, to which he contributed not only illustrations and cover designs but poetry as well.[14] The quality of his illustration, particularly in his Modernist manner of illustrating women, had already reached a standard sufficiently sophisticated for him to have been hired by the Platon Company, a publisher of Western-oriented popular periodicals including *Josei* (*Woman*)[15] and *Kuraku* (*Joys and Sorrows*). The chief designer of the Platon Company was Yama Rokurō (1897–1982), an artist strongly influenced by Aubrey Beardsley. Another young designer, Maeda Mitsugu (1903–67), had also been hired by Platon, and within a relatively short time both had became known for stylized, Westernized women in their designs. During Yamana's few years

18

with Platon, his exposure through his cover illustrations for the above-mentioned, widely popular periodicals had given him increasing visibility. It was possibly his acquaintance with Maeda, who was the first to move on to Shiseido, that brought him to the attention of the senior management there. The chief designer was Sawa Reika (1896–1970), and chief of the design section was Takagi Chōyō. By the late 1920s the design and style of this firm had already set it apart as one of those most readily identifiable in its use of Western forms in its graphics for numerous product lines. Yamana extended and refined the house style, which had elements of Art Nouveau "Beardsleyisms"— together with increasing interjections of Modernist elements.

Maeda and the Shiseido photographer Ibuka Akira were to create another Modernist stream within the Shiseido design program.[16] The *Home Calendar*, a substantial promotional booklet of some fifty pages, was published November 1, 1930, and distributed at the beginning of the following year. The use of photography and photomontage in what could be considered a Modernist manner in this and other Shiseido promotional pieces was the work primarily of Maeda and Ibuka. But the rather jarring use of photomontage by Maeda and Ibuka as a centerfold in the *Home Calendar* provides a sharp and not particularly harmonious contrast to Yamana's typical stylized women, who appeared throughout in a delicate, asymmetrical layout.

Yamana left Shiseido in 1931, rejoining it from 1936 to 1943 and then again from 1948 to 1980.

When Yamana took his design skills elsewhere, Shiseido did not abandon its mainstream Modernist advertising look but continued to promote its products with a tendriled style not unlike that of the leading Parisian cosmetic firms of the time. By the end of the 1930s, however, Shiseido, with Yamana once again involved, seemed to be retreating into a more conservative style. Not until the early 1950s was the firm to recover the leading role in graphic design it had enjoyed in the late 1920s and early 1930s. Yamana was once again a key figure, this time in rebuilding Shiseido's war-reduced advertising department.

THE NEW PHOTOGRAPHY AND JAPANESE ADVERTISING

The coquettish wine-drinking young woman in the 1922 Akadama Port Wine poster by Inoue Mokuda and Kataoka Toshirō (1882–1945) is the image frequently cited in discussion of photography's advent in Japanese poster advertising. It is undeniably the most successful of early incorporations of photography and design in a Japanese poster, but it is by no means the first. The makers of Pearl Perfume had used a photographic poster of a young woman in front of a Western-style mirror in 1908, and it is quite conceivable that there were even earlier experiments with photography and advertising.

Japan's history of photography began in earnest with the 1862 establishment of photographic studios in Nagasaki by Ueno Hikoma and in Yokohama by Shimooka Renjō (1823–1914).[17] But the owners of Pearl Perfume may well have begun the photo-poster revolution, as there is no earlier recorded photo-

This 1922 poster by Kataoka Toshirō and Inoue Mokuda won the first prize in the Werbe-Kunst-Schau in Nürnberg the same year.

poster. The following year saw something of a mini-explosion, when, in 1909 alone, photo-posters appeared promoting Club Washing Powder, Pasta-musk Soap, Misono Face Powder, Daigaku Face Powder, Kunji Perfumed Oil, and other types of merchandise. In all these examples, however, it is only the model, and often only the face, that is photographed, while the background is painted.

The Inoue and Kataoka poster set an aesthetic high standard as well as being something of a turning point in content: it was the first Japanese photographic poster to use a nude model. The quality of the reproduction was attributed to the arrival in Japan of color photoengraving technology through the HB Tokyo Seihan Company, established in 1920. International attention was drawn to this poster when it was entered in the Werbe-Kunst-Schau Exhibition in Nürnberg in 1922 and received the first prize.

This famed poster also marked something of a departure in expression and hairstyle in women depicted in poster, packaging, and newspaper advertising from 1908 on. The Bijin-ga, or image of a beautiful woman with Japanese hairstyle, almost-innocent eyes, and closed lips, gave way to the modern, Western image. The coquettishness of the woman in the Akadama Port Wine Poster was soon thereafter replaced by a more direct, less seductive expression.

Use of photography in Japanese advertising in any sense that could be called Modernist did not come in a substantial way until nearly a decade after the success of Inoue and Kataoka. Use in film posters and on covers of weekly and monthly film magazines from the mid-1920s on was not uncommon. But this was more on the order of straightforward use by Yamada Shinkichi (1904–82) in the poster for a Harold Lloyd film of 1924.

The way for the New Photography (Shinkō Shashin) was being prepared by Kimura Senichi, editor-in-chief of *Photo Times* (1924–41). *Photo Times* carried a regular feature, "Modern Photo Section," that published articles on trends and theory as well as photos by such leading representatives of the modern movement in photography as Moholy-Nagy, Herbert Bayer, Man Ray, Otto Umbehr, Edward Steichen, and Margaret Bourke-White. Experiments with photomontage and photograms were included along with commentary. One regular contributor to the journal was Ibuka Akira, the photographer working for Shiseido. In addition to writing about applications in commercial photography for the journal, he introduced photomontage applications to Shiseido advertising, along with Maeda. In general, the circle around *Photo Times* looked somewhat condescendingly upon the representatives of the pictorialist school of photography, including among others the work of the Shiseido heir Fukuhara Shinzō (1883–1948).[18]

If one were to cite a turning-point work in this change in Japan in the practice of photography and its ultimate effect on advertising design, it was

Hara Hiromu's poster for the fourth annual Japanese photo contest, 1930.

that a derived Art Nouveau style was still negatively identified as modern in the eyes of public and client. (In the United States it was sentimental realism that sold products in this period, also with attendant reluctance to bring in any Modernist photographic application.)

A tangential tie to *Photo Times* was the appearance of *Kikai to geijutsu tono Kōryū*[19] in 1929, a book that was to prove of some influence to a number of photographers of the period. The author, Itagaki Takaho (1894-1966), promoted a "mechanical aesthetics" that essentially celebrated the relationship of art, architecture, and machines in the ever-changing cityscape. Horino Masao (b. 1907), the photographer for this book, was a regular contributor to *Photo Times*. Horino also produced the widely influential work of the New Photography *Kamera/Me X Tetsu/Kōsei* (*Camera/Eye X Iron/COMPOSITION*), in 1932, and is recognized as a Japanese pioneer in this Modernist photographic style.[20] Another figure of importance is Koishi Kiyoshi (1908–57), whose *Shoka Shinkei* (*Early Summer Nerve*), published in 1933, is also one of the representative works of the New Photography in this period. Koishi was a prize winner in the second International Exhibition of Advertising Photography, in 1931.

There were certainly others in the rapidly changing advertising photography scene of the late 1920s and early 1930s.[21] In 1926, Kanamaru Shigene (1900–77), a member of Sugiura

the discussion in *Photo Times* of Moholy-Nagy's "typo-photo" theory in his *Malerei Photographie Film* (München, 1925). Despite such evidence of changing interest in photography, there remained the dilemma for Japanese advertising designers that was the problem for designers in all ideographic-language countries: the integration of letterforms and photography into printing. A design-culture factor also was an impediment in the late 1920s in

Hisui's Studio Collective, The Group of Seven, and Suzuki Hachirō (1900–85), who was working in the editorial division of a photography magazine, founded Kinrei-sha, the first professional studio in Japan for advertising and promotion photography. After 1929 the studio came under Kanamaru's sole control and the work began showing an emphasis on close-ups strongly influenced by the New Photography as practiced in Germany. Among the important clients of Kinrei-sha were the Calpis Food Company Limited, Yamasa Soy Sauce, and Morinaga Candy Company. In some cases, the client commissioned design as well as photographic services.

Adding to the cumulative general effect on advertising design of *Photo Times* and its circle and the studio Kinrei-sha were a number of other photographers. Meriting mention in the move away from the pictorialist style early on was the peripatetic Nakayama Iwata (1895–1949), who experimented with photograms in his Paris studio in the spring of 1927. On his return to Japan later that year, after nearly ten years, Nakayama exhibited a selection of his work at the Asanuma Company's gallery in Tokyo. Much of it showed the influence of his time in New York (1918–26), Paris (1926–27), and Berlin (1927).[22] Another photographer moving past the pictorialism that had dominated Japanese photography and exhibiting at various camera club shows was the Osakan Yasui Nakaji (1903–42).[23] Yasui, unlike Nakayama, remained a photographer outside the design world. He exemplified the amateurs among the growing number of photographers working in a Modernist, nonpictorialist manner.

Kimura Ihei (1901–74), proprietor of a conventional studio in Nippori, was also in the process of rejecting the pictorialist style and even turning away from earning a stable living through portraiture. He spent much of his time searching through the "real" and not necessarily beautiful mid-1920s Tokyo for images that, when viewed today, demonstrate unequivocally how the concept of the New Photography was taking root.[24] In 1931 an important next step in the advancement of the New Photography in day-to-day application took place when Ōta Hideshige, the art director of a leading soap company and a Christian Socialist, saw Kimura's stark, show-all-the-blemishes photographic style and commissioned him to do a series of photographs for a newspaper advertising campaign designed by Asuka Tetsuo (b. 1895). One advertisement showed a woman obviously of the underclass bending over a washtub, a tumbledown dwelling in the background and clothes hanging on a makeshift line in the foreground. Another Rodchenkoesque style has the reader/viewer looking up from an electric railway embankment at power lines that seems to support structures and at the man-in-the-moon logo of Kaō Soap, which floats incongruously in the sky. These grainy, black and white advertisements accomplished more than satisfying the social conscience of Ōta; they opened the way for a Modernist use of photography in the venue with the widest audience.

Up to the close of the 1920s, Japanese photographic pictorialism was exemplified by the work of Fukuhara Shinzō and the monthly journal of the photographic club that he initiated in 1921, *Shashin-Geijutsu* (*Photographic Arts*), and by the influential books of pictorialist photographs that he

A Kaō Soap newspaper advertisement of 1931 (Tokyo). This series campaign was designed by Asuka Tetsuo and incorporated the photographs of Kimura Ihei, one of the leading Modernist photographers of the time.

published.[25] Ironically, Fukuhara Shinzō was an heir to the fortune of the Shiseido Company, whose advertisments in Modernist style was helping the New Photography to rapidly crowd out pictorialism, at least among intellectuals and the advertising avant-garde. Shinzō's younger brother Rosō (1892–1946) responded to these new tendencies. His own visibility as one of the heirs to the Shiseido fortune helped him and other forerunners of conse-

quence to move many of the cognoscenti toward a general reception of the New Photography, with all that entailed for advertising graphic design. (The photography of Rosō in the last years of the 1920s echoes in some respects the work of the German photographer Albert Renger-Patzsch, both in subject matter and approach.)

These pioneers in the New Photography provided the necessary intellectual preparation for what ensued in photographic design applications following the arrival of the "Film und Foto" exhibition in Tokyo and Osaka in 1931. Despite its being reduced in size from the Stuttgart show, it was to have a far-reaching effect on Japanese photographers and designers by acquainting the exhibition visitors with a still wider range of Modernist photographers. Of particular importance for the commercial design community was the opportunity for many to see for the first time the work of Piet Zwart and Paul Schuitema.

The "Film und Foto" exhibition may also have been one of the stimulants to the initiation of what is generally considered the most influential periodical for Modernist photography: *Kōga*. Nakayama, Nojima Yasuzō, Kimura Ihei, and Ina Nobuo (1898–1978) founded *Kōga* in May 1932.[26] In its brief life, lasting until December 1933, this journal added to the work begun by *Photo Times* by influencing the new generation of Japanese graphic designers, the generation of Hara Hiromu, Imatake Shichirō, Kōno Takashi, and Kamekura Yūsaku. A glance at a

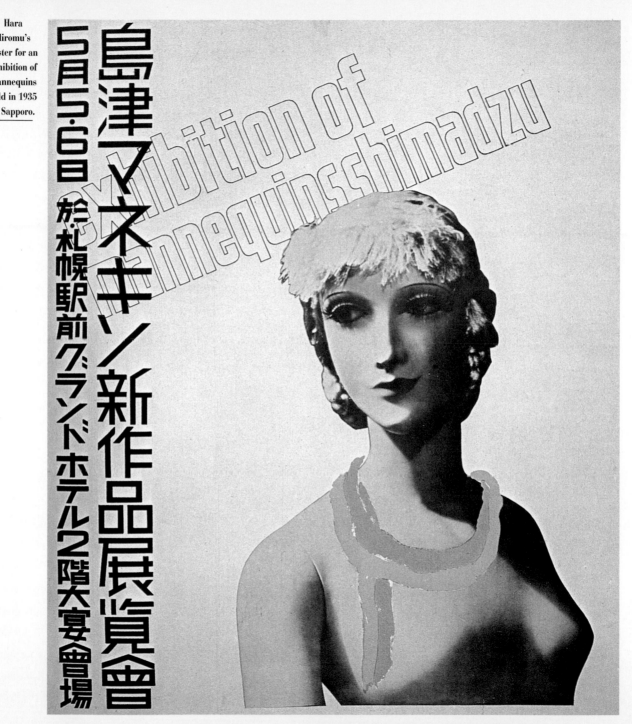

Hara Hiromu's poster for an exhibition of mannequins held in 1935 in Sapporo.

few article titles gives some indication of the ideas and images circulating in Japan as the result of this journal: "Painting-Photography, Letter-Typography, and Typophoto," by Hara H.; "The Present Phase of Photographic Art in Japan and its Crisis," by Ina Nobuo; "Photomontages of Kurt Kranz," by Yamawaki Iwao (1898–1987); "Photographic Works of El Lissitzky," by Hara H.; "For the Centenary of J.-N. Niepce," by Ina Nobuo; and by an unidentified author, "Protest against 'The Seasons in Japan,' the Propaganda Film produced by the Japanese Government Railways." But it was Ina's article "Return to Photography," in the first issue, that served as a manifesto of sorts for the New Photography in Japan. The journal's emphasis on the New Photography diminished as the emphasis on photoreportage increased in its final issues. Thus Kōga's influence on commercial design employing photography is limited to its earlier issues.

By 1929 one of Kōga's founders, Hara Hiromu, had begun to explore possibilities of the photo in poster design. His stylized use of the photo continued right into the mid-1930s and perhaps is at its best in his Shimazu Mannequin Exhibition poster of 1935. (Kimura Ihei provided the photograph.)[27]

A certain lingering of the "beautiful woman" style, or Bi Jin-Ga referred to earlier, was still noticeable in the late 1920s, despite its general rejection among the leading designers of the decade. Sawa Reika's 1929 poster for Lait Crème (Shiseido) employs the "beautiful woman" style despite its photomontage approach. The projection of timeless beauty (the seashell) and purity (the innocent-looking, smooth-skinned model) conveys a clear message. The seamless, airbrushed typography looks modern. But the poster is not in the Modernist tradition and it does not echo the design talk of the time in the way that Hara's mannequin poster does. Despite Sawa's continuing involvement with Shiseido, there was a noticeable regression there, not only in the cover design of its publicity organ. In general its magazine advertising[28] showed a trend to a more traditional use of photography, but no more so than the then-current practice in the United States. The cover design of Shiseido's periodical Hanatsubaki hit squarely in the comfortable, reassuring style of sentiment being created similarly in the United States in the commercial work of Grancel Fitz, Edward Steichen, Valentine Sarra, and Anton Bruehl in the early and mid-1930s.

A second impetus to the use of the New Photography in graphic design in general and advertising design in particular came at about the same time that troubles were developing at Kōga. In 1932 Natori Yōnosuke, mentioned earlier for his founding role in graphic art direction, returned from his studies at the Technical University in Munich. He came back not only with ideas but also as a correspondent for Ullstein publishing company's Berliner Illustrierte and its other periodicals. Natori began in that same year his Nippon Kobō, a studio/agency, with the dream and goal to merge photography, graphic design, and to some degree the fine arts. Joining Natori in this venture were Hara, Ina Nobuo, Kimura, and Okada Sōzō (1903–83). Natori's experiences with photojournalism

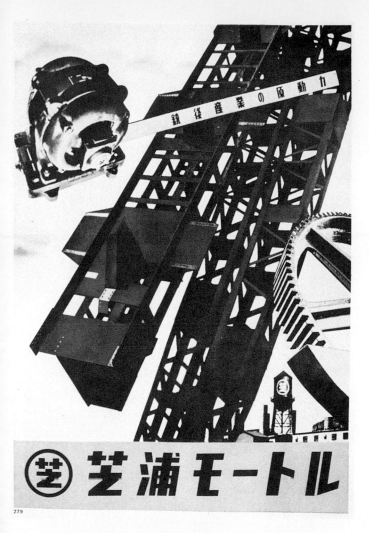

鉄後産業の原動力

㊟ 芝浦モートル

279

A photomontage designed in 1938 by Kamekura Yūsaku (photography by
Domon Ken) for the Shibaura Motor Co. (Tokyo).

in Munich gave him the concepts for the next phase of
his career, and in the end these ideas directly and indi-
rectly affected newspaper and periodical advertising
graphics in Japan as well as having some influence on
Japanese poster design.[29] Most important for him was
his encounter with the work of Felix H. Man (pseudo-

nym of Hans Felix Baumann). Natori's encounter with
Man explains something of the German press photo
style observable in his agency's work. The year 1933
was a turbulent one at Nippon Kobō. Hara, Ina, and
Kimura left, and the studio/agency became inactive.
But Natori revived it again in 1934 and over time
attracted to his staff Domon Ken (1909–90) in 1935,
Fujimoto Shihachi (b. 1911), and Kamekura Yusaku
in 1937. Natori then conceived the idea of *Nippon*
(1934–44), a multilingual (English, French, Spanish,
and German) periodical intended to encourage trade
through introducing Japanese culture abroad. This
pioneering effort in graphic journalism relied heavily
on photography and on spaciousness in its carefully
structured layout. The high quality paper and superior
design certainly set it apart from other Japanese peri-
odicals of its time. Of major importance for the devel-
opment of *Nippon* and the development of graphic
design in Japan was that Natori attracted Kamekura,
Kōno Takashi, and Yamana Ayao to *Nippon*.

The covers with and without photographs and the
internal layout that this team created remain fresh
sixty years later. *Nippon* exemplified total design inte-
gration for periodicals. Kawahata Naomichi maintains
that Natori's conception for *Nippon* was influenced by
his exposure to such diverse periodicals as Ludwig
Roselius's *Die Böttcherstrasse* (Bremen, 1928–30), with
its sumptuous format; Bruno Werner and Fritz
Hellweg's *Die Neue Linie* (Leipzig, 1929–43), with its
integrated page layout and advertisements and with
extensive use of photography and photomontage;
and later, Henry Luce's *Life* (1936–72).[30] Unques-

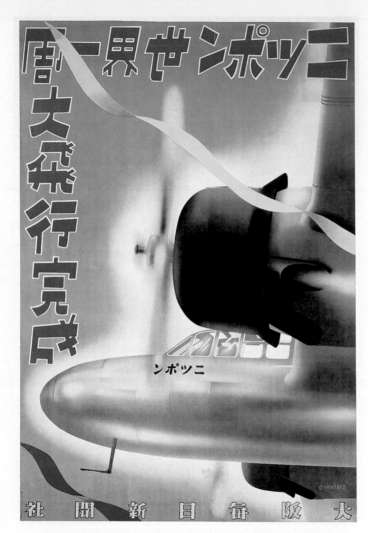

世界一周 大飛行完成 ニッポン号

ニッポン号

大阪毎日新聞社

Imatake Shichiro's poster design for the completion of Nakao Sumitoshi's
around-the-world flight in 1939. Advertiser: Osaka Mainichi newspaper.

period. Kamekura and Domon Ken's collaboration on the late-constructivist photomontage poster for the Shibaura Motor Company in 1938 is but one example. Hara's posters for photo exhibitions continued to show his incomparably deft balancing of photography and typography. The Fourth Annual Amateur Photo Competition in 1930, with its three visual planes, echoes the style for which Herbert Bayer was already becoming known. The photomontage pamphlet of Imatake Schichiro for Takashimaya Department Store (Osaka) in 1937 and the promotional brochure for a food subscription program a year later for the same store fit the Modernist style as well. Imatake's "Flight Around the World" poster of 1939 and his 1940 poster for a government-sponsored scrap metal drive are something of a compromise; although based on photographs, they are basically airbrush creations. Others by this group remain distinctive examples of "photomontage Modernism."[31]

It might be interjected at this point that there is a tendency to define graphic design trends in terms of particular cities, and with good reason. The commercial centers of any country tend to attract designers with talent. Tokyo is the focus or implied focus of much of the writing about Japanese graphic design. Osaka, Kobe, and other commercial centers also had established design communities throughout the 1920s and 1930s, the decades addressed here. One personality who with his associates illustrates this point

tionably *Nippon* could hold its own from a design/printing standpoint among the major cultural periodicals of the time.

Photographic elements in the design of advertising posters by these "Nippon Kōbō men" in the 1930s are now part of the graphic folklore of the

is Imatake, who has maintained his office in Osaka from the 1930s to the present, continuing to claim his position in the forefront of graphic design trends.

What has already been said about the New Photography and its application to poster design, periodical cover design, and smaller graphics applies as well to newspaper advertising and packaging design in this period. For packaging in particular, photography was used only in a modest way throughout the 1930s, and when used it was in a manner little different from that in any other industrialized nation. A photo of the product was incorporated into the label or package design. The application to poster and periodical design was decidedly brighter, and it was the leading designers and photographers who were responsible for the examples that can be safely grouped under the heading of Japan Modernism.

With the onset of World War II, Modernist approaches in all applications of commercial graphic design were generally less frequent. Advertising design practice returned to the principles of design of any nation at war—that is, heroic idioms, sentimental representation, and images glorifying the ideals of the nation. A number of the leading designers and photographers were conscripted into the war effort. A few continued to apply modern principles; the "war work" of these is witness to the fact that a number of young designers did not give in to pressures for the type of realism usually associated with war-effort graphics. For examples one need only look at issues of *Front* (1941–45)[32], a propaganda magazine under the oversight of the Military General Staff Office but published by a private publishing house, Tōhō-sha, founded in 1941. Hara was chief of the art department and Kimura was head of the photography department, which also included the now-renowned Hamaya Hiroshi (b. 1915). In consistent application of Modernist principles of photomontage and photo design, *Front*'s overall design equaled that of *USSR in Construction* even in the latter's best years. There was a smoothness to the integration of photos. The fact that each of the six double and two single issues was more or less theme oriented also contributed to the unity of design in each issue. *Front* was certainly indebted, with particular irony, to both *USSR in Construction* and *Life*.[33]

Much of the Modernist influence reflected in the war mobilization posters, general magazine design, and even some newspaper advertising remains anonymous. But in just a random browsing through the World War II sections of such compilations as *Posters Japan 1800s–1980s*[34] one sees the aftershine of Japanese Modernism—a legacy that survived (along with some of its creators) and took new life in post–World War II Japan, as once again Japan looked West not only for graphic design inspiration, but for a new style of political participation on the international scene.

nyone interested in pursuing Western Modernist graphic influences in ephemeral Japanese commercial graphics of the mid-1920s to the mid-1930s must consider, at least in passing, the matchbox covers of that era. Surprisingly, it is this one tendency, the Modernist, that Joan Rendell does not discuss in her otherwise invaluable *Matchbox Labels* (New York: Praeger, 1968). Unlike matchbox and/or matchbook covers in many industrialized nations, this commodity in Japan is a major design resource.

The matchbox production for domestic consumption is of primary interest. Bars, department stores, political parties, bookshops, and restaurants used the matchbox for domestic advertising. Unfortunately, we know little of the designers engaged in this type of design. Few have come forward to claim or identify their work. It was perhaps considered too transitory. Only a few in our sample of over three thousand from the few years between 1924 and the late 1930s can be identified as to designer or even dated with any degree of accuracy. Yet judging from the general quality of the several thousand designs surveyed for this work, designers of recognizable talent worked in this medium. The box designed for local use, as distinct from that which was designed for export, often reflects a talent that transcends the mediocre work so frequently associated with this humble package. Not surprisingly, even record of the restaurants and bars named in the designs has vanished or, if it exists, does not contain information as to designer or date of design. Exceptions are

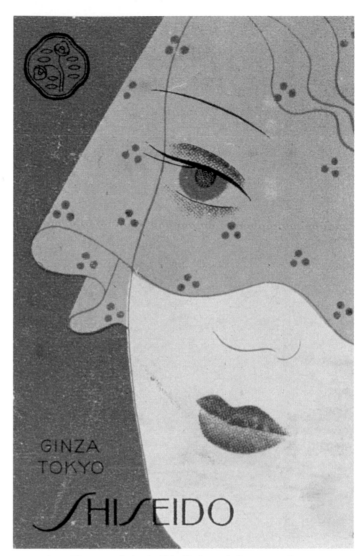

GINZA
TOKYO
SHISEIDO

A matchbox cover design for Shiseido Cosmetic Company, mid-1930s.

mainly among such large companies as Shiseido Cosmetic Company. Though its extensive surviving archive identifies a number of Shiseido matchbox designs according to designer and date, none of the matchbox covers shown here has substantial documentation.

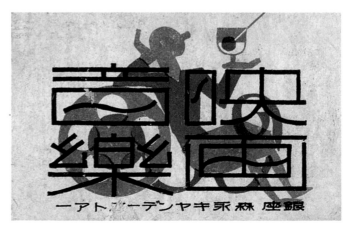

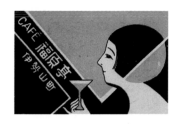

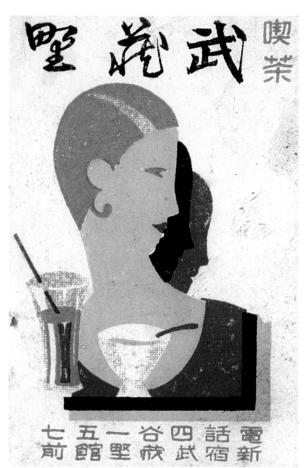

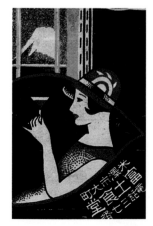

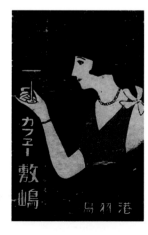

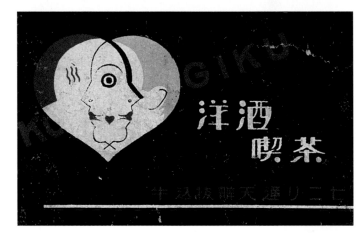

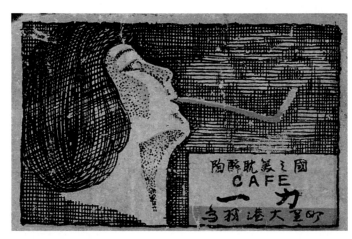

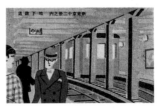

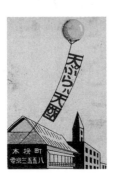

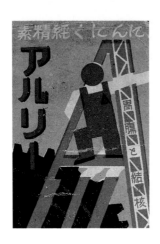

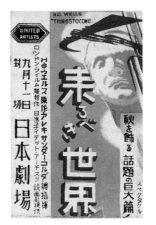

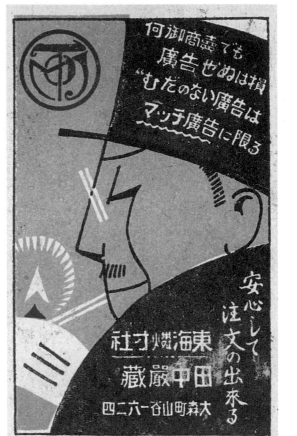

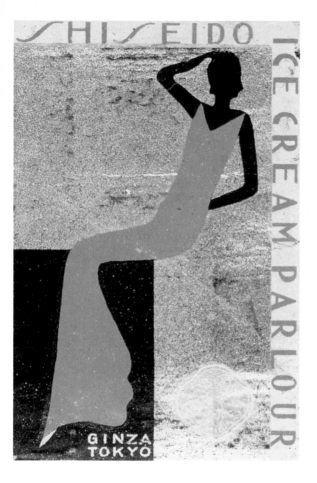

SHISEIDO ICE CREAM PARLOUR

GINZA TOKYO

上野洋品店
硨文谷ハ〇
持原富士舘前角

DAIMARU

ハンターのプレッシング

ツボンノ折目タテハキチン
ト付ケテカラ御出カケ
下サイ

パンツ 10 SEN

三階

as to s
BAR streak
MANHATTAN
of essays "Maku
four seasons of
pleasant thing
酒場 マンハッタン
四谷塩町
電燐

ヤマヤス靴店
大久保百人町八六

幸ビル 寒梅

菓子と
喫茶

Primo Angeli, in his introduction to *Trademarks of the 20's & 30's* by Erik Baker and Tyler Blik (San Francisco: Chronicle Books, 1985), could just as well have been speaking of Japan in that era in his comment about trademarks in the United States: "... these graphic expressions can also be read as cultural barometers. Each one is a short story, an ideogram of the decade, an episode that contributes to the whole era ... clear visual evidence of the transition from a rural-agricultural economy to an urban-industrial one ..." Many of the Japanese trademarks of the 1920s and 1930s had their origin in the *kanban* or signboards used by merchants to identify the products sold in their shops. The range of content in the advertising images was as varied as the imagination of the vendors. Departure from what might be considered traditional Japanese aesthetic principles was the norm. Although often stylized with some degree of sophistication, such stylization had more to do with the lack of flexibility of the weather-resistant medium used (wood) than an attempt to be graphically interesting. But *kanban* were often grotesque, and the trademarks derived from these signboards more often than not carried on this fashion.

In 1884, legislation had been passed requiring that trademarks be registered. This registration may have had a role in the simplification of images, when in some instances where a vendor was also a producer the transfer was made from a wooden shop sign to a stamp or label used on each product. By the mid-1920s the use of English words in trademarks, even in the phrase "Trade Mark," had become commonplace. Images from the West were just as frequently used, as one sees in the examples shown here.

For dating and information on the trademark registrant, the data given in the records of the Japanese National Patent Agency are the most accurate. In some cases the product can be determined from the mark. Others require a bit of guessing, as the mark appears to have no relation to the goods being produced. The name of the company or the owner appears in captions. The city or prefecture given is either the site of the manufacturer's main office or the city from which the trademark application was filed. When trademark use did not take place until the year following registration, the trademark year is followed by a + sign.

The 1934 trademark for the Modern Girl Company of Wakayama-shi, a producer of silk and woolen fabrics.

1 Kisha
food sauces
Asahikawa, 1932+

2 Sakuta
clothing, buttons,
accessories, hand towels
Osaka, 1936

3 Asahi Tank
clothing, buttons, hand
towels, accessories
Osaka, 1937

4 Air-Light
playing cards
Kyoto, 1936

5 Kamon
underwear, handkerchiefs,
towels
Osaka, 1936+

6 Imperial Tabi, Inc.
clothing, tabi, socks,
accessories, hand towels
Okayama, 1930+

7 Hikōshōnen
chemicals, medicine
Aichi Prefecture, 1934

8 Ginpa
fireworks
Fukuoka, 1923

1

2

3

4

5

6

7

8

44

9

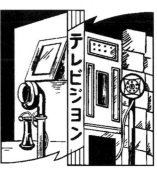

10

11

12

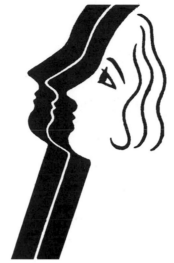

13

14

15

16

17

9 **Nakazuka Shōten**
 liquor, Osaka, 1936

10 **"Television"**
 chemicals, medicine,
 medical supplies
 Osaka, 1928

11 **Tabako**
 matches
 Osaka, 1930

12 **Nakao** *Company Owner*
 paper, paper products
 Tokyo, 1935+

13 **Ōta** *Company Owner*
 metal containers for powder
 products, Osaka, 1934

14 **Ōyoshi**
 chemicals, medicine,
 medical supplies
 Yahata, 1928

15 **"Hollywood"**
 inhalers
 Tokyo, 1929

16 **Talkie**
 clothing, buttons,
 accessories, hand towels
 Osaka, 1930

17 **Oku**
 Company Owner
 steel wire, Osaka, 1936+

18 Kaō, Inc.
Soap, Tokyo, 1930+

19 Kitamura *Company Owner*
cake, bread
Osaka, 1936+

20 Kawashima *Company Owner*
stationery supplies
Tokyo, 1930

21 Riola
toothpaste
Tokyo, 1937

22 Mōso
chemicals, medicine,
medical supplies
Osaka, 1937

23 Mori *Company Owner*
chemicals, medicine,
medical supplies
Osaka, 1930

24 Mori *Company Owner*
cake, bread
Kobe, 1936+

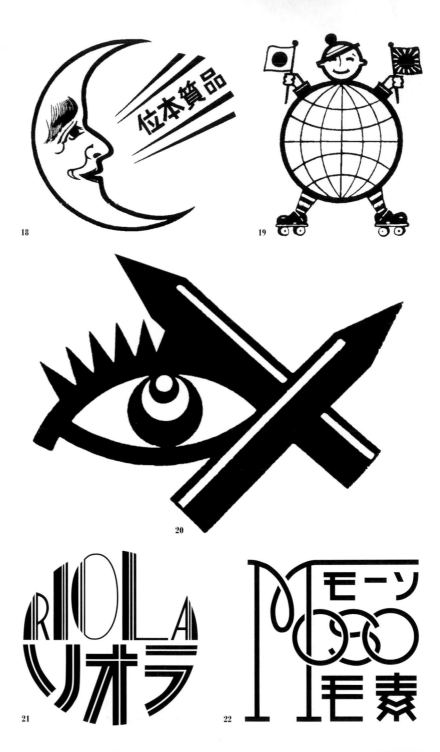

23

24

25

26

28

27

25 Hardhead
agricultural tools
Tokyo, 1935+

26 Oyama *Company Owner*
chemicals, medicine,
medical supplies
Fukuoka, 1930+

27 Happō Bijin
powdered and liquid soap
Utsonomia, 1923

28 Nodoka
candy
Osaka, 1929+

POSTERS

A case could be made for telling the history of Japanese graphic design from the Meiji era to the present solely through the evidence of the poster. Advertising posters in the form known in the West began appearing in the early part of the 1870s. With the establishment of the Lithograph Engraving Company Limited, in Tokyo in 1872, the means were available. Credit also should be given to the unsung Western teacher of the lithographic process to this company's staff, Ottoman Smolick (dates and citizenship unknown).

According to Ogawa Masataka, the first lithographic posters in Japan were being produced about 1881 for the tobacco merchant Fuchigami-ya. From that time until the first decade of this century, when Sugiura Hisui began his poster making with the Mitsukoshi Company, was the beginning of art-directed poster design by artists who saw the potential of the medium in the sense pioneered by Jules Cheret, Edward Penfield, Alphonse Mucha, and others. Prior to that time, Japanese poster making was limited mainly to illustrated broadsheets and poster-sized sheets created by anonymous printing office staff. From the time of Sugiura's poster announcing the opening of the Mitsukoshi Dry Goods Store in its new Nihonbashi Building to the present, the poster has been a primary medium in Japan. Even so, the development of poster design before the early portion of the third decade is not of primary concern. While the development of Modernism draws on this early period, it is the dramatic change that took place after 1923 and the opportunity for a fresh start brought

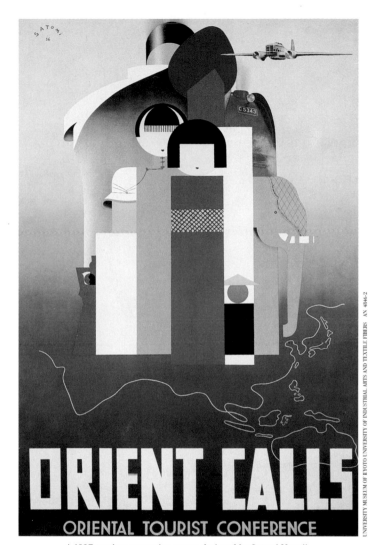

A 1937 tourism promotion poster designed by Satomi Muneji.

about by earthquake that are illustrative. Thus the posters shown here are essentially the second stage in Japanese poster history, for what is shown represents the period of transition from traditional images to images dominated by Western currents of design. But it must be remembered that any selection presented

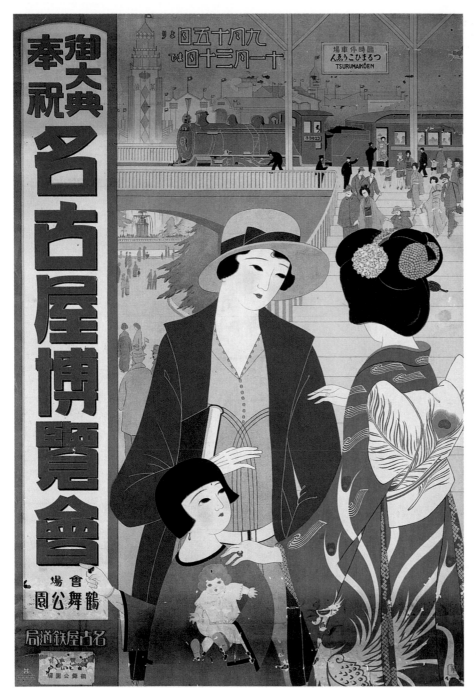

Poster announcement by an unknown designer for the Nagoya Exposition of autumn 1926.

to illustrate this second era shows a far from seamless record: the so-called era of Modernism in Japan has multiple graphic trends running side by side. At times they converge. Many works in this period contain an incongruous combination of elements of several trends. What follows in this selection of posters suggests basic trends in Japanese poster design from the mid-1920s to the late 1930s.

Note: Posters 60 through 63 are known only from a catalog of Japanese and European posters produced by government communications agencies (for the post, telegraph, airlines, and others) titled: Zuan shiryō posutā shū *(Tokyo: Teishin Hakubutsu-kan, 1937). The designers/artists are unknown and, as with data for some other posters, it has not been possible to provide measurements. All in this series are likely to have been published between 1935 and the compilation's 1937 publication date.*

1 **"Kirin Stout. The Beer We Drink in Winter."**
Advertiser: Kirin Brewery
Artist: Tada Hokuu
(1889–1948)
Date: 1934

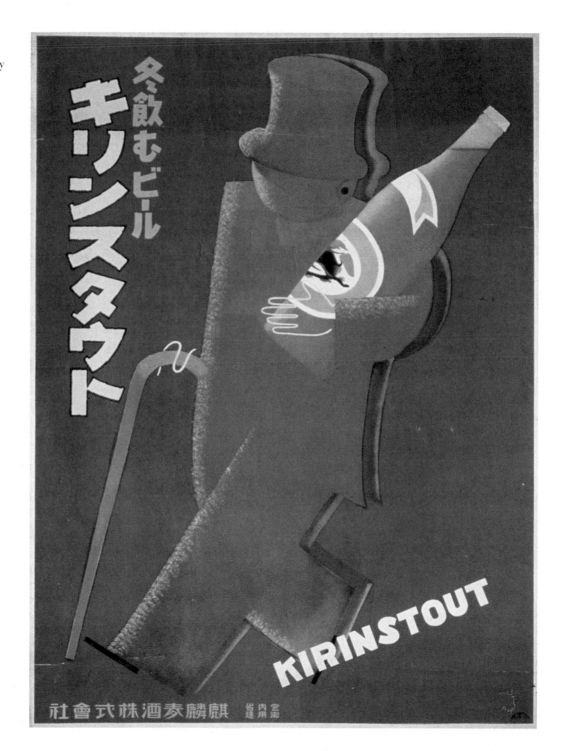

2 **"Calpis. Good, Refreshing, Nutritious, Good for your Digestion"**
Advertiser: Calpis Food Co.
Artist: Unknown
Date: 1932

3 **"Calpis"**
Advertiser: Calpis Food Co.
Artist: Akabane Kiichi
Date: 1937

4 **"Kirin Beer"**
Advertiser: Kirin Brewery
Artist: Tada Hokuu
Date: 1937
Size: 91 x 61.5 cm

5 **"Kirin Stout"**
Advertiser: Kirin Brewery
Artist: Tada Hokuu
Date: 1936
Size: 77 x 54 cm

6 **"Kirin Stout"**
Advertiser: Kirin Brewery
Artist: Tada Hokuu
Date: 1936
Size: 75 x 53 cm

2

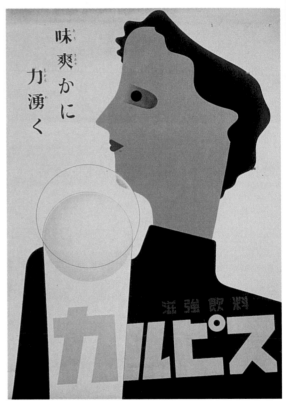

3

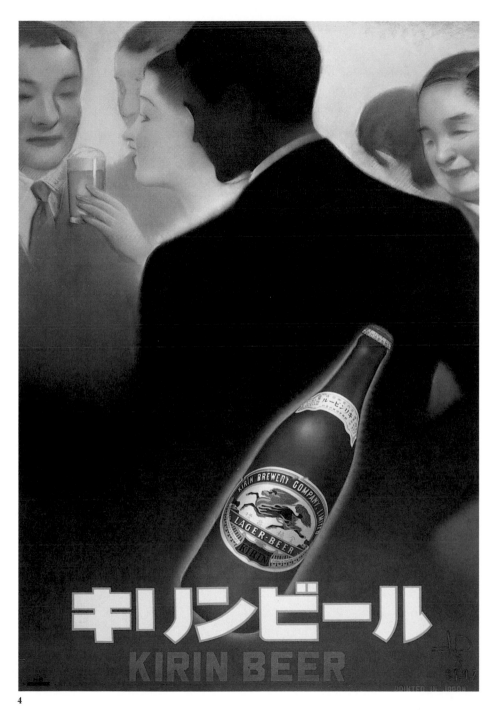

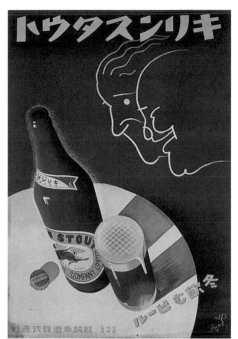

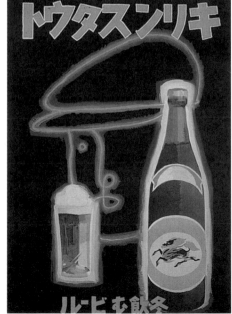

4

6

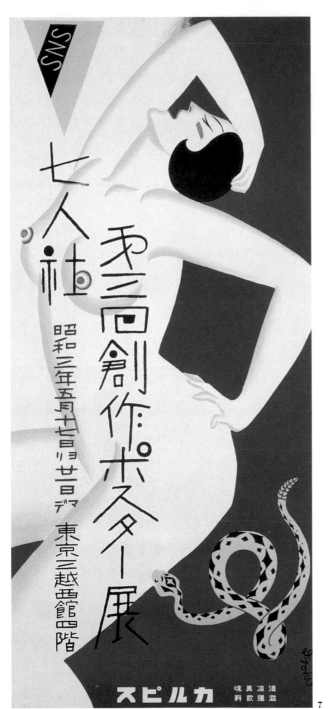

7

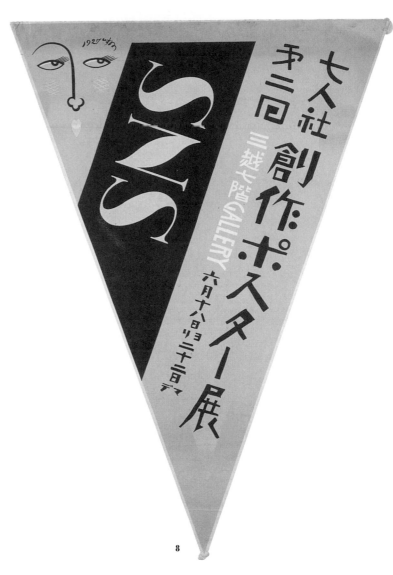

8

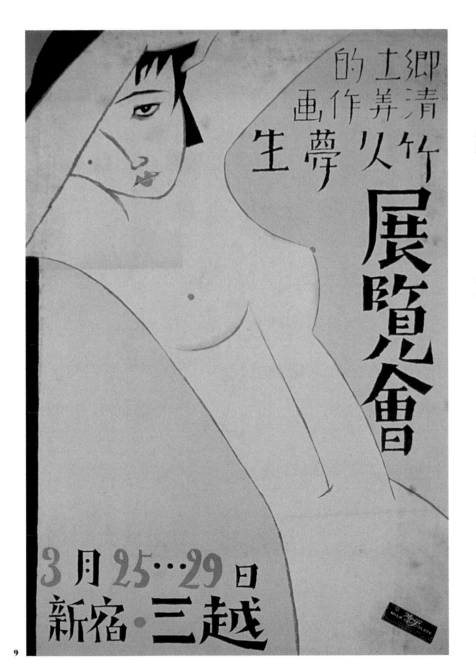

7 "**Third Original Poster Exhibition of the Group of Seven.**"
Artist: Sugiura Hisui
Date: 1928
Size: 77 x 35 cm
Note: Held at Mitsukoshi Department Store Gallery.

8 "**Second Original Poster Exhibition of the Group of Seven.**"
Artist: Sugiura Hisui
Date: 1927
Size: 76 x 55 cm
Note: Held at Mitsukoshi Department Store Gallery.

9 "**Takehisa Yumeji Exhibition**"
Artist: Takehisa Yumeji (1884–1934)
Date: 1931
Size: 58 x 39 cm
Note: Held at Mitsukoshi Department Store Gallery.

10 "International Dance Exhibition"
(Tokyo, Ueno Park)
Artist: "Rik"
Date: Early 1930s
Size: 105 x 77 cm
Note: Held at Matsusakaya
Department Store Gallery.

11 "Exhibition of Olympic History"
Sponsor: Japan Physical
Training Association
Note: Held at Shiroki-ya
Department Store Gallery.

12 "The Beauty of Modern Architecture"
Sponsor: Marubutsu
Department Store
[at Kyoto Station]

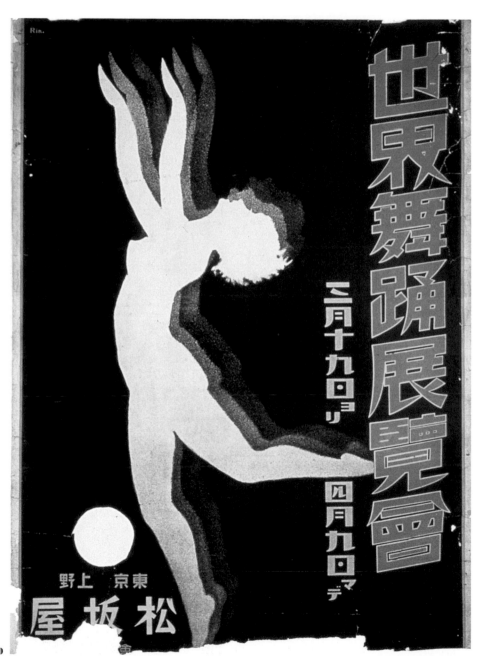

10

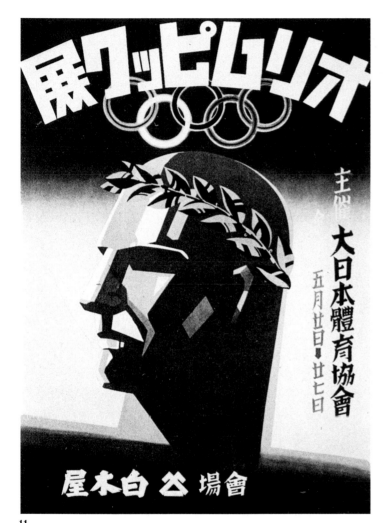

11

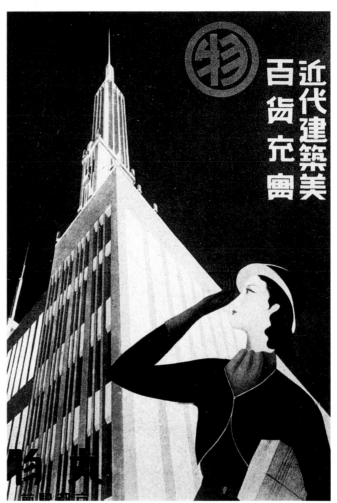

12

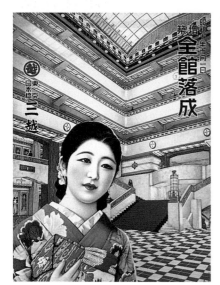

13

13 Mitsukoshi Department Store

Artist: Tada Hokuu

Date: 1935

Size: 106.5 x 77.7 cm

Note: This poster illustrates the retreat into a more conservative style of design noticeable among many firms after 1934 as the government began moving to the political right and nationalist spirit began to grow.

14 Teikoku Ranpu

Advertiser: Teikoku Lamp Co.

Artist: Machida Ryūyō (1871–1955)

Date: 1926/27

Size: 78 x 53 cm

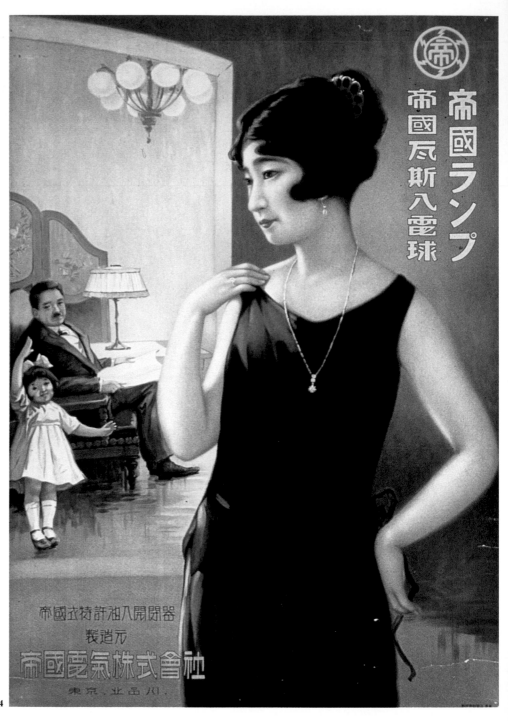

14

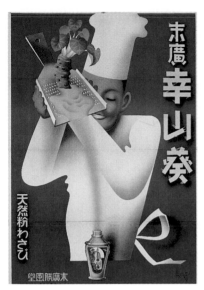

15

16

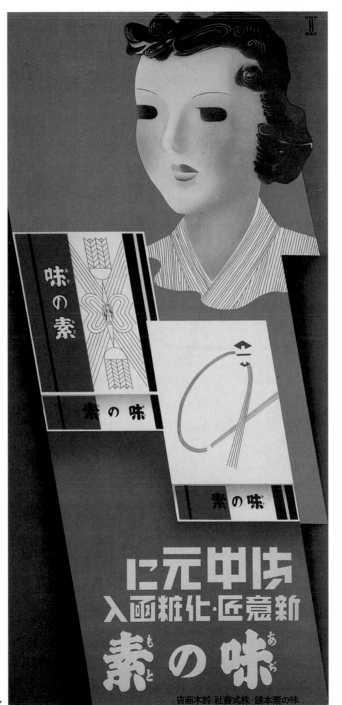

17

15 "Suehiro Horseradish
 Powder"
 Advertiser: Suehiro
 Shōfūdō (Osaka/Tokyo)
 Artist: Kawamura Unpei
 (1906–66)
 Date: 1938
 Size: 79.3 x 54.7 cm

16 "On-the-spot-sale.
 Specialty products.
 Flea Market"
 Advertiser: Organizers
 of the Ōita Prefecture
 "Spot Sale"
 Artist: Unknown
 Date: Early 1930s
 Size: 78 x 52 cm

17 "Summer Gift"
 Advertiser: Ajinomoto-
 Honpo Co. (a seasoning
 manufacturer)
 Artist: Ōchi Hiroshi
 (1898–1974)
 Date: 1933?
 Size: 76 x 35.5 cm

18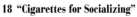

18

19

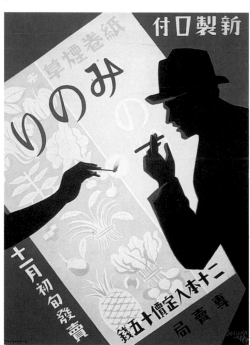

20

18 **"Cigarettes for Socializing"**
 Advertiser: Kyoto Nambu Tobacco Retail Union
 Artist: Unknown
 Date: 1937
 Size: 53.2 x 38.2 cm

19 **Hibiki cigarettes**
 Advertiser: Senbaikyoku
 Artist: Nomura Noboru
 Date: 1932
 Size: 53 x 38.5 cm

20 **Minori cigarettes**
 Advertiser: Senbaikyoku
 [Japan Tobacco and Salt Public Co.]
 Artist: Sugiura Hisui
 Date: 1930
 Size: 53 x 38.5 cm

21

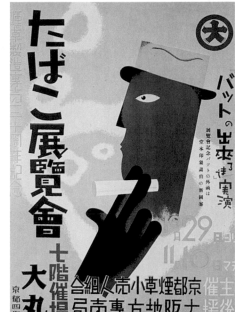

22

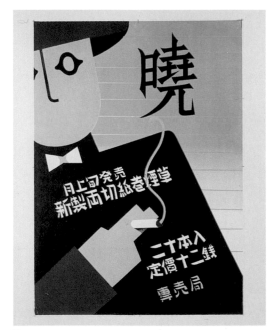

23

24

21 Goal cigarettes
Advertiser: Nanyang Bros.
Tobacco Co., Ltd.
Artist: Unknown
Date: 1938
Size: 28.9 x 22.4 cm

**22 Exhibition of Tobacco
Products** (in Kyoto)
Advertiser: Kyoto Nambu
Tobacco Retail Union
Artist: Unknown
Date: 1935
Size: 53.2 x 37.9 cm

23 Akatsuki cigarettes
Advertiser: Senbaikyoku
[Japan Tobacco and Salt
Public Co.]
Artist: Nomura Noboru
Date: 1932
Size: 53.3 x 37 cm

24 Kohaku cigarettes
Advertiser: Senbaikyoku
Artist: Uekusa Shihoo
Date: 1930
Size: 78.3 x 53.8 cm

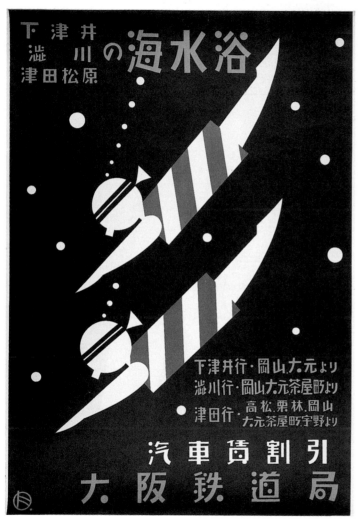

25

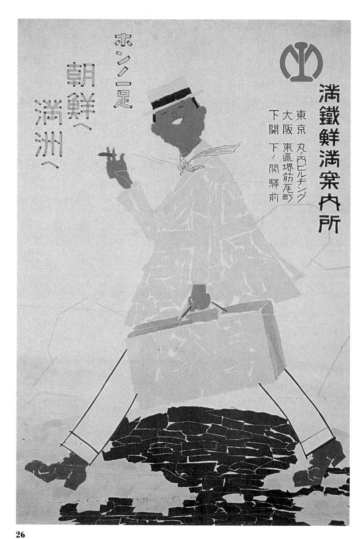

26

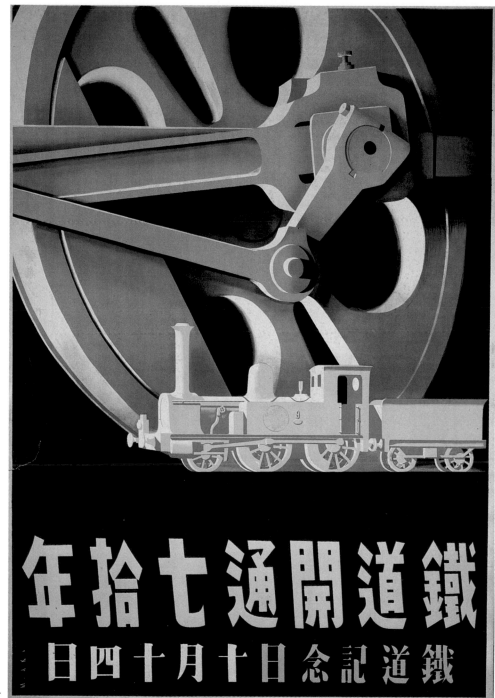

27

25 Ocean Swimming
 Advertiser: Osaka
 National Railway
 Artist: Toyonosuke
 Kurozumi (1908–55)
 Date: Mid-1930s
 Size: 77.5 x 54 cm
Note: Kurozumi gave a gentle
and unified image of leisure
for Osaka Railway Bureau
posters and pamphlets from
the early- to late 1930s.
Kurozumi resigned from the
railway after the war and
opened a photo shop in Kobe.

26 "Let's go to Manchuria
 and Korea"
 Advertiser: Manchurian-
 Korean Railway
 Artist: Unknown
 Date: Late 1930s

27 "Commemorating Seventy
 Years of the Opening of the
 Railway in Japan, October
 14th is Railway Day"
 Advertiser: Japan Ministry
 of Railways
 Artist: Unknown
 Date: 1940
 Size: 83.4 x 59.5 cm

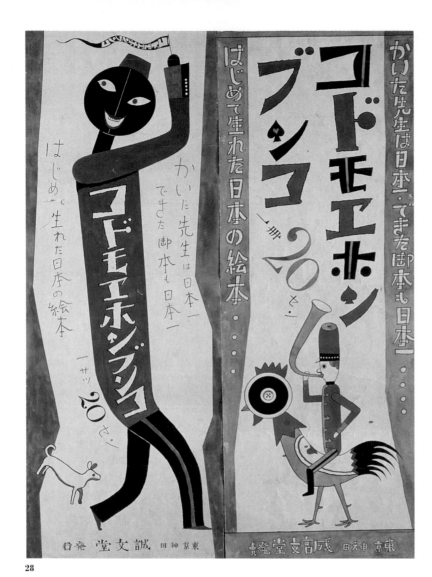

28

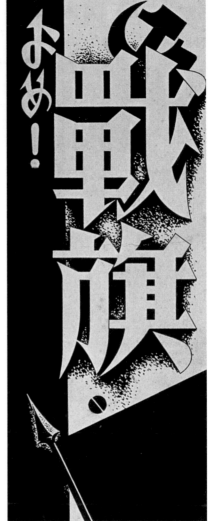

29

28 *Kodomo Ehon Bunko*
 Bookseller: Seibundo (Tokyo)
 Artist: Takei Takeo (1894–1983)
 Date: 1928/29?
 Size: 55 x 20 cm

29 "Senki. Read it!"
 Advertiser: Senki Publication Co.
 Artist: Yanase Masamu
 Date: 1930
 Size: 25.3 x 9.8 cm
Note: Senki (Fighting Flag) *was one of the leading left-wing periodicals of the time.*

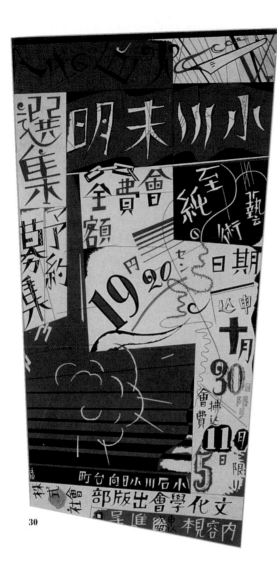

30

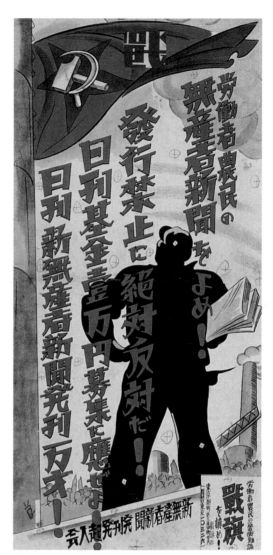

31

30 "Selected Works of Ogawa Mimei. Subscribe now."
Advertiser: Bunka Gakkai Shuppanbu
Publishing Company
Artist: Yanase Masamu
Date: 1925
Size: 77.3 x 40.5 cm
Note: Ogawa Mimei, a novelist and children's writer, moved from the Japan Socialist League to the Japan Fabian Society and finally joined the anarchist movement in the mid-1920s.

31 "Read the Musansha Shimbun (Proletarian Newspaper)! We're protesting the government order prohibiting this paper!"
Advertiser: Musansha Publishing Company
Artist: Yanase Masamu
Date: 1929
Size: 53.5 x 26 cm

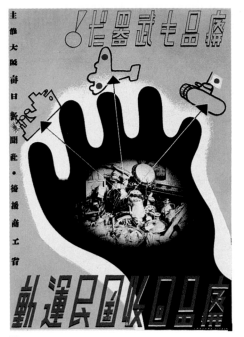

32

32 "Even Scrap Metal Can Be a Weapon"
Advertiser: Osaka Mainichi Newspaper
and the Japanese Ministry of Commerce
Artist: Imatake Shichirō
Date: 1942
Size: 105 x 78 cm

**33 "Shake Hands with Fifty Thousand Readers.
Read the Musansha Shimbun"
(Proletarian Newspaper)**
Advertiser: Musansha Shimbun Publishing Co.
Artist: Yanase Masamu
Date: 1927
Size: 54.5 x 39.5 cm

34 "The Nine Most Talked About Magazines"
Advertiser: Dai Nippon Yubenkai [a few of the
titles are: *Modern Times*, *Boys Club*, *Girls Club*],
Kōdansha Publishing Co. (Tokyo)
Artist: Tada Hokuu
Date: 1930s
Size: 91 x 61.5 cm

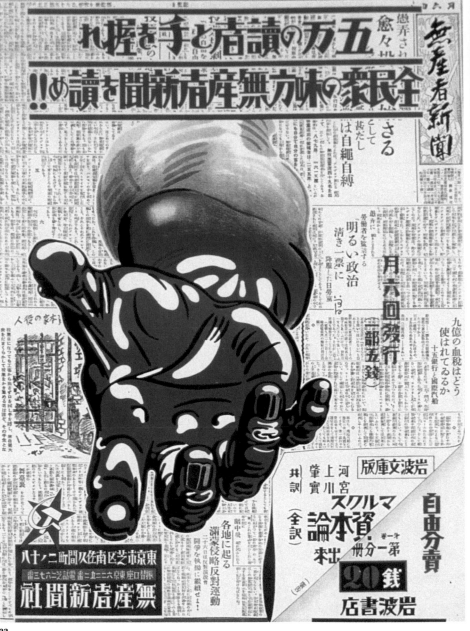

33

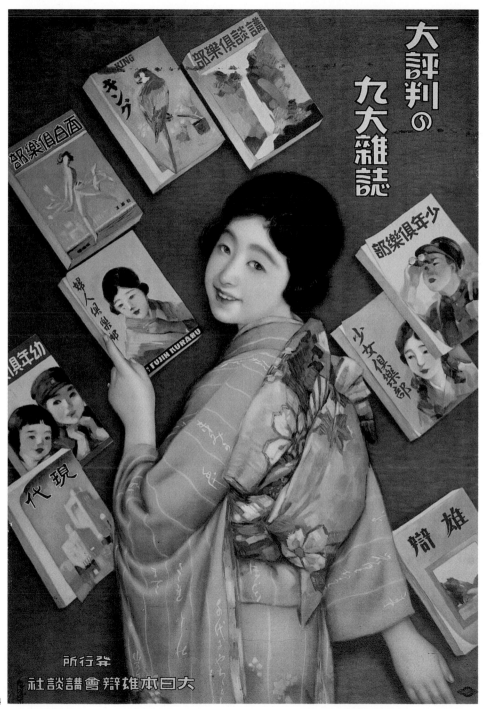

35 *Bungei Sensen*
[LITERARY FRONT]
Artist: Yanase Masamu
Date: 1924
Size: 44.9 x 30.4 cm

36 "World's Greatest Writers"
Artist: Yanase Masamu
Date: Late 1920s
Size: 60.6 x 30.5 cm

37 "[The] Postal System; Our Pride"
Sponsor: Japan National Post and Telegraph

38 "Air Mail between Shinkuo (Manchuria) and Tokyo Takes But One Day"
Sponsor: Manchurian Airways Ltd.

39 "Air Routes Are Being Extended"
Sponsor: Japan Air Transportation Co., Ltd.

35

36

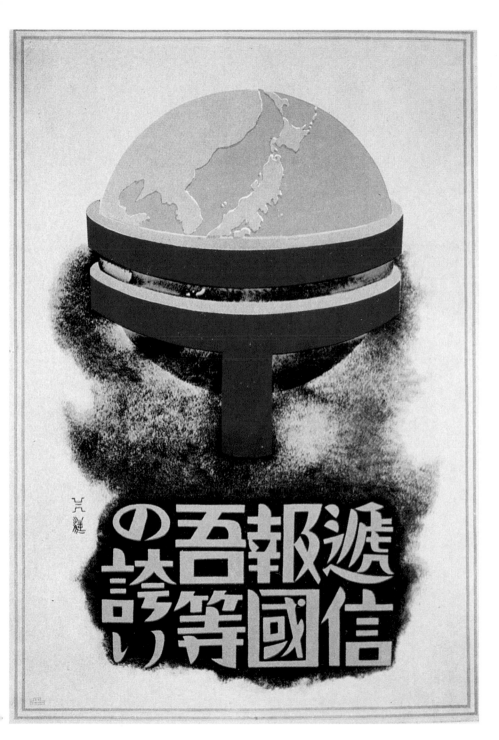

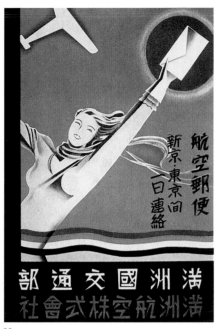

38

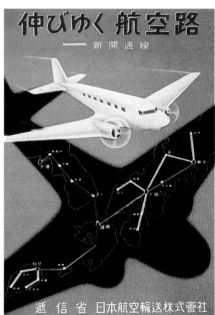

39

40 **"[Harold] Lloyd, the
Popular Person" (a double
feature with "Salome")**
Advertiser: Shōchikuza
Film Co. (Tokyo)
Artist: Yamada Shinkichi
Date: 1924/25
Size: 53.7 x 24.6 cm

41 **"Decennial Performance of
the Sawada Shōjirō Theatre
Group"**
Artist: Unknown
Date: Late 1920s
Size: 54.3 x 40 cm

42 **"A Call for Exhibiting at the
Proletarian Art Grand
Exhibition"**
Advertiser: Five left-
wing associations and
companies*
Artist: Unknown
Date: 1928
Size: 53.2 x 38 cm
**Note: Association of Plastic
Artists, Committee of
Proletarian Artists
Organizations, All-Japan
Proletarian Artists Association,
Proletarian Newspaper
Company and the Workers'
and Farmers' News Company.
Held at the Tokyo
Metropolitan Art Museum.*

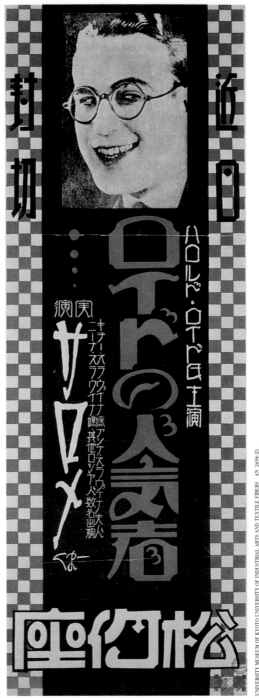

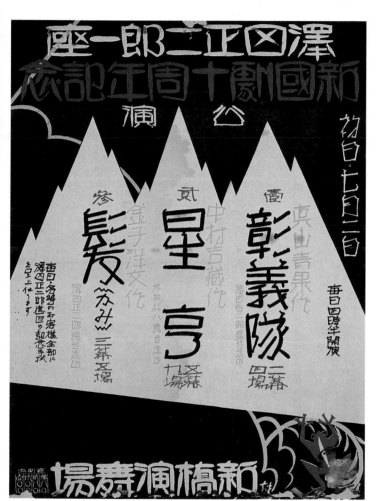

41

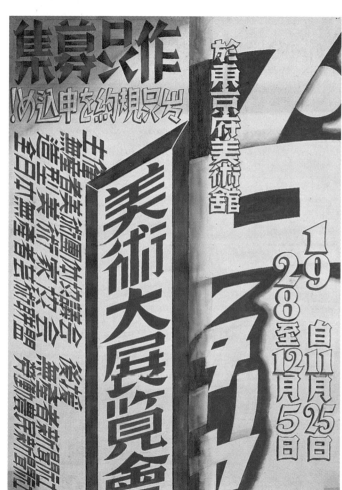

42

43 Theatre bill for the "Third Dress Rehearsal" by the Senku-za Group
Artist: Yanase Masamu
Date: 1924
Size: 78.8 x 35.3 cm

44 Theatre bill for the "Second Public Performance" by the Zenei-Za Group
Artist: Yanase Masamu
Date: 1927
Size: 76.1 x 53.4 cm
Note: Held at the Tsukigi Shogekijo Theatre, Tokyo.

45 "Biography of a Woman: An Old Tale of Korea"
Advertiser: The Shinkyō Gekidan Theatre Group
Artist: Kōno Takashi
Date: 1938
Size: 134 x 73 cm

46 "The Lady and the Beard"
Artist: Kōno Takashi
Date: 1931
Size: 106 x 73 cm
Note: For a film directed by Ozu Yasujirō.

47 A multiple feature including the 1929 release of *Dry Martini* costarring Mary Astor and Matt Moore
Advertiser: Asakusa Talking Film Co.
Artist: Unknown
Date: 1929/30?
Size: 75.8 x 52 cm

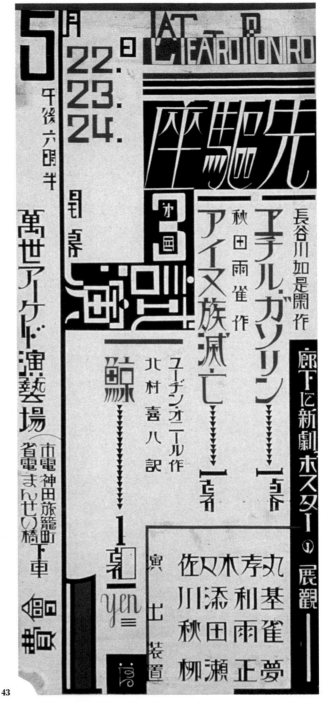

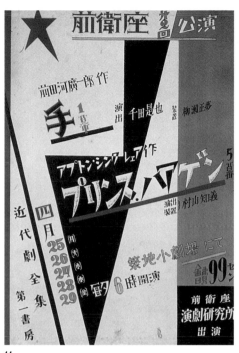

44

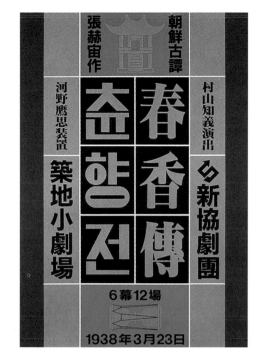

45

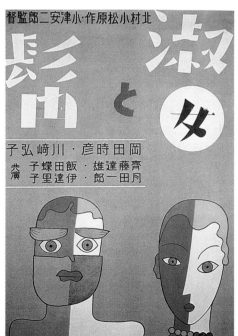

46

47

48

50

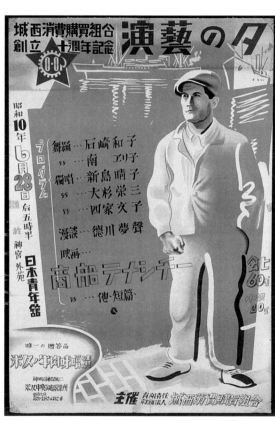

51

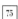

48 Art Exhibition "Sanka Members Exhibition" and Performing Art Exhibition "Gekijō no Sanka"
Artist: Murayama Tomoyoshi
Date: 1925
Size: 51.6 x 39.9 cm

49 "Nero"
Advertiser: Shōchiku-za Film Company
Artist: Yamada Shinkichi
Date: l924
Size: 53.6 x 24.6 cm

50 "The Paper Balloon..." Starring Kawarazaki Chōjūrō and Kiritachi Noboru
Advertiser: Tōhō Movie Company
Artist: Yamashita Kenichi
Date: Unknown

51 "Evening of Entertainment"
Sponsor: Consumers' Buying Union
Artist: Yanase Masamu
Date: 1935
Size: 79.3 x 53.2 cm
Note: The program includes "The Merchant Ship Tenacity."

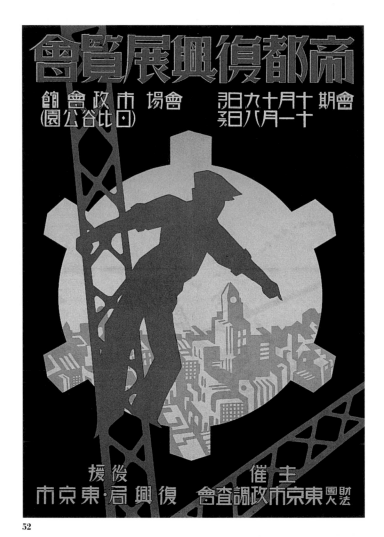

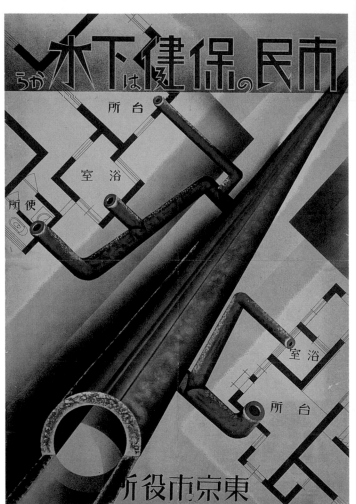

52

53

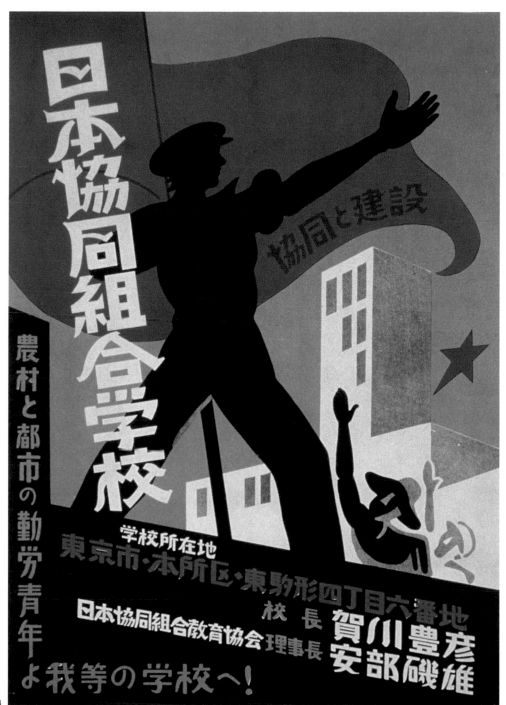

54

52 **"Exhibition of the Reconstruction of Tokyo. Oct. 9-Nov. 8. Ilibiya Park Municipal Building"**
Advertiser: The Institute for Municipal Research/Reconstruction Bureau of the Tokyo Municipal Government
Artist: Unknown
Date: 1929
Size: 75.5 x 53.2 cm

53 **"The Sanitation of Cities Starts with a Sewage System"**
Advertiser: Tokyo Municipal Office
Artist: Unknown
Date: Mid-1930s
Size: 75.8 x 52.8 см

54 **"Japan Cooperative School. Come to our school, young workers on the farm and in the city!" Starring Kawarazaki**
Advertiser: Japan Coopertive Education Association
Artist: Yanase Masamu
Date: Late 1920s
Size: 54.8 x 39.4 cm

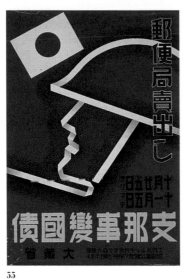

55

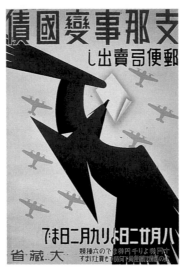

56

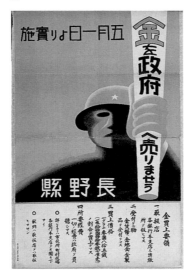

57

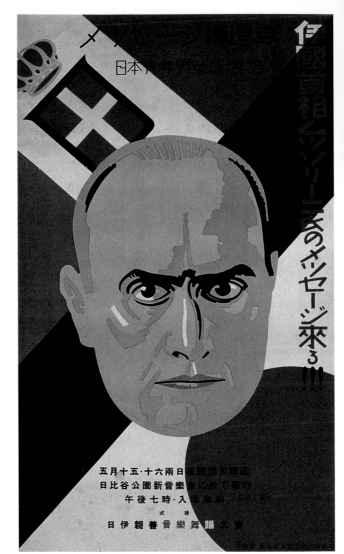

58

55 "National Bond for the China Incident"
 Advertiser: Ministry of Finance
 Artist: Unknown
 Date: 1937
 Size: 77.4 x 52.4 cm

**56 National Bond Drive for the
 China Incident**
 Advertiser: Ministry of Finance
 Artist: Ōhashi Tadashi (b. 1916)
 Date: 1937
 Size: 63 x 36.2 cm

57 "Sell Your Gold to the Government"
 Advertiser: Nagano Prefecture
 Artist: Unknown
 Date: 1941
 Size: 80 x 53 cm

*Note: The text elaborates on the war mobiliza-
tion effort program of exchanging gold for
coupons that in turn could be exchanged for
goods.*

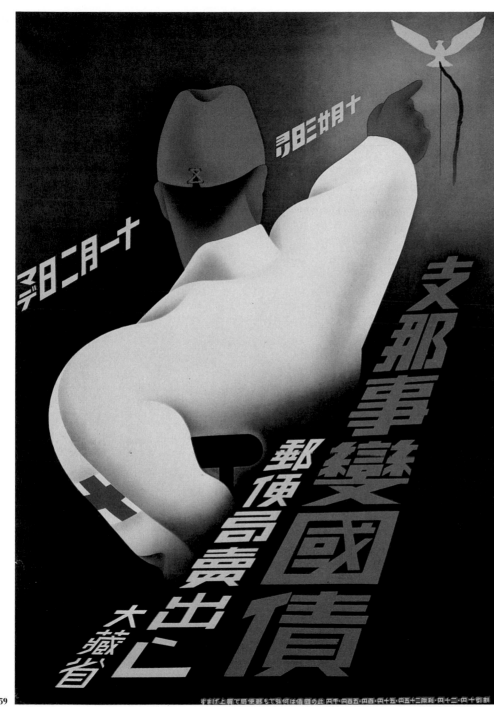

58 "The Italian Prime Minister Mussolini's Message Just Arrived! To the Youth of Japan. To Enhance Friendship between Japan and Italy. Dance Party Following"

Advertiser: Calpis

Artist: Sugiura Hisui

Date: 1926

Size: 63 x 37 cm

Note: Calpis was and is a major soft drink and food company. Dance Party held May 15/16, Hibiya Park, New Music Hall.

59 "National Bond for the China Incident Now on Sale at the Post Office"

Advertiser: Japanese Ministry of Finance

Artist: Unknown

Date: 1937

Size: 53.4 x 37 cm

Note: The wounded soldier is pointing to the bird symbolic of Japan's founding, implying that he, the wounded soldier, is ready to do even more for his country.

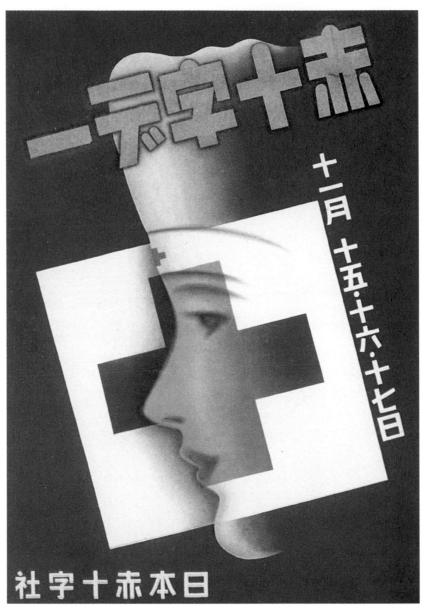

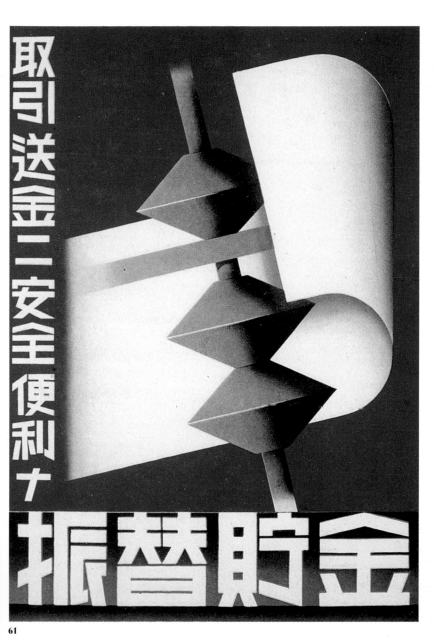

61

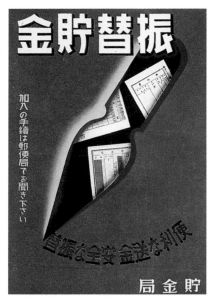

62

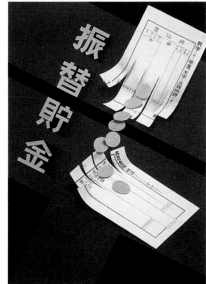

63

64 "Eudermine"
 [liquid face powder]
 Advertiser: Shiseido
 Artist: Yabe Sue
 Date: 1925
 Size: 29.2 x 21.2 cm

65 Toothpowder
 Advertiser: Shiseido
 Artist: Unknown
 Date: 1927?
 Size: 17 x 24.4 cm

66 "Cremoline. Our Gift with Your Purchase"
 Advertiser: Shiseido
 Artist: Maeda Mitsugu
 Date: 1932
 Size: 107 x 38.5 cm

67 "Rujisuchikku"
 [rouge stick]
 Advertiser: Shiseido
 Artist: Maeda Mitsugu
 Date: Ca. 1933
 Size: 26 x 38 cm

68 "Oiderumin Oshiroi"
 [Eudermine liquid face powder]
 Advertiser: Shiseido
 Artist: Mori Noboru
 Date: Ca. 1933
 Size: 26 x 38 cm

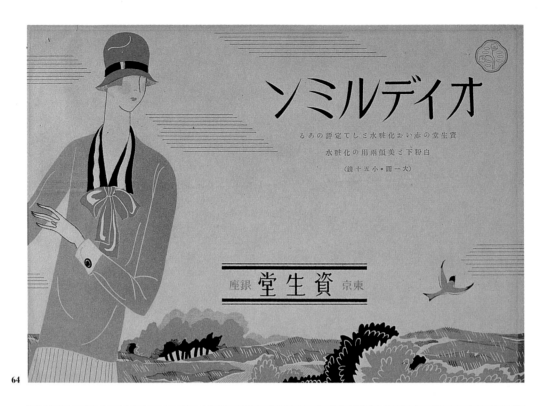

64

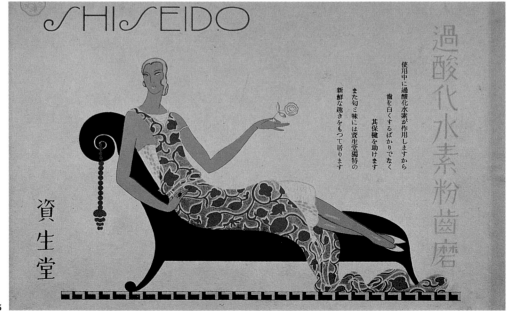

65

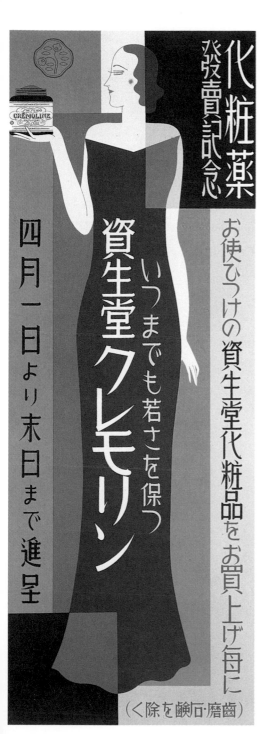

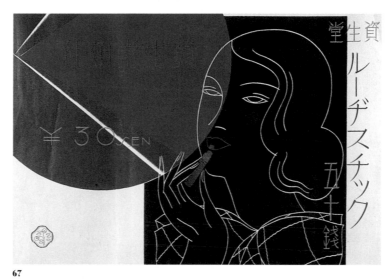

67

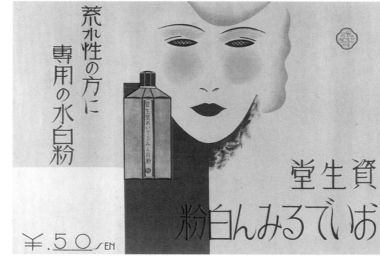

68

69 **"Asahi Shoes. Strong,**
Inexpensive, Light"
Advertiser: Nippon Tabi
Co. Ltd.
Artist: Unknown
Date: Mid-1930s
Size: 78 x 53 cm

70 Victor records
Advertiser: Victor Talking
Machine Co.
Artist: Takabatake Kashō
(1888–1966)
Date: 1930
Size: 68 x 33 cm
*Note: The model holds the
disc containing "Solveig's
Song," released by Victor in
1929.*

71 "Victrola. Portable"
Advertiser: Victor Talking
Machine Co.
Artist: Unknown
Date: Early 1930s
Size: 75.7 x 52.6 cm

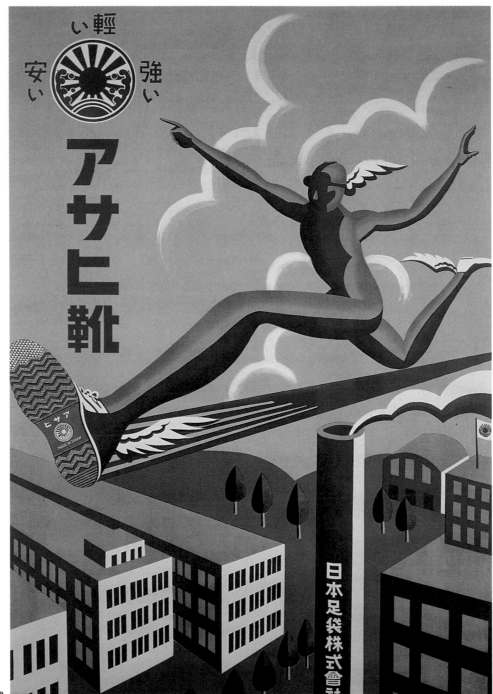

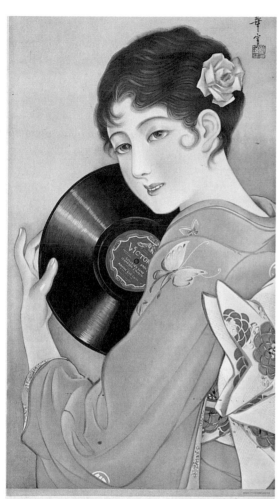

70

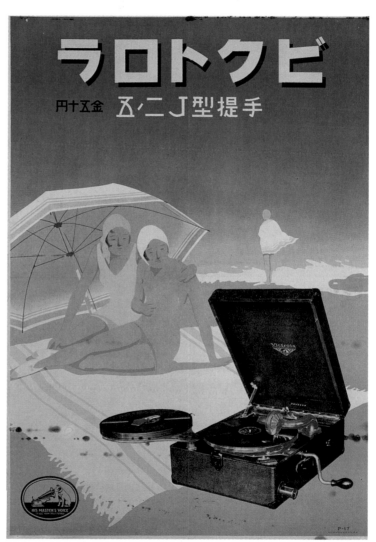

71

From the mid-1920s to the mid-1930s, compendia of Western graphic design were published in Japan to serve a varied clientele including store owners, designers working for commerce, and students. The most noted such work was *Gendai-shōgyō-bijutsu zenshū*. Its title in English was *The Complete Commercial Artist*. It was available by subscription (with retail merchants being the primary subscribers) from June 1928 to September 1930, when the twenty-fourth volume appeared. The conception and editorial management of this major undertaking was that of Hamada Masuji (1892–1938), a designer and leading design theoretician of the 1920s. The editorial committee working under Hamada consisted of Watanabe Soshū, Tatsuke Yoichirō, Nakada Sadanosuke, Miyashita Takao, and Sugiura Hisui.

This unconventional publication by Western encyclopedia standards contained reports on the status of commercial art month by month. Through this means the theories and works of the major movements of the time were conveyed in a practical way. Many readers were able for the first time to see applications of the theories of the Bauhaus, the Soviet avant-garde, and various manifestations of constructivist design, as well as to see the application of theories being developed by the three leading coalitions of Japanese designers: the Association of Commercial Artists (founded and led by Hamada), the Group of Seven (led by Sugiura), and the Osaka Association of Commercial Artists. In the first volume an example of this "idea transmission" is an essay by Nakada on the constructivist poster design of Lajos Kassák. The final volume contained a hundred-plus-page

"Survey of Commercial Art" written by Hamada that is considered of incomparable importance for the theoretical guidance of designers in the 1930s. Owners of stores and shops of varying size and with projects of varying complexity could find in *The Complete Commercial Artist* the latest design guidance as well as practical models for show windows, promotional materials, posters, signs, packaging, and display fixtures.

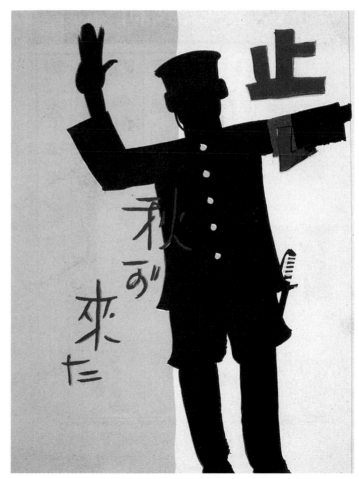

"Stop! Autumn has come." A design idea by Tada Hokuu highlighting seasonal change opportunities for retailers. From Murota Kurazō album of Western design ideas from 1931 (see p. 88).

Hamada's contributions did not stop with this major undertaking. In 1931 he published the four-volume textbook for commercial art *Shōgyō bijutsu kyōhon* (Tokyo: Toyama-shobō), and in 1935, a work on the principles and structure of commercial art titled *Shōgyō bijutsu kōusei genri* (Tokyo: Kōyo-shoin). All the while he was actively contributing articles to various publications, notably the commercial art periodical *Kōkoku-kai.* Hamada was also deeply involved in the Institute of Commercial Art, which he founded in 1929, a major force for design education in Japan.

A much more modest undertaking was Murota Kurazō's series of portfolios with loose, mounted examples titled *Shōten zuan sensyū (A Selection of Designs for Shops,* published in Tokyo: Seibun-dō). Besides examples chosen from *The Complete Commercial Artist,* most here have been chosen from Murota's third compilation, published in 1931. Only two of the works shown are signed and only one has been identified. Unless otherwise indicated, all illustrations measure 21.5 by 15.5 cm and all presumably were created between 1929 and 1931. Illustrations from Murota's compilation are those without volume and page numbers in the pages that follow.

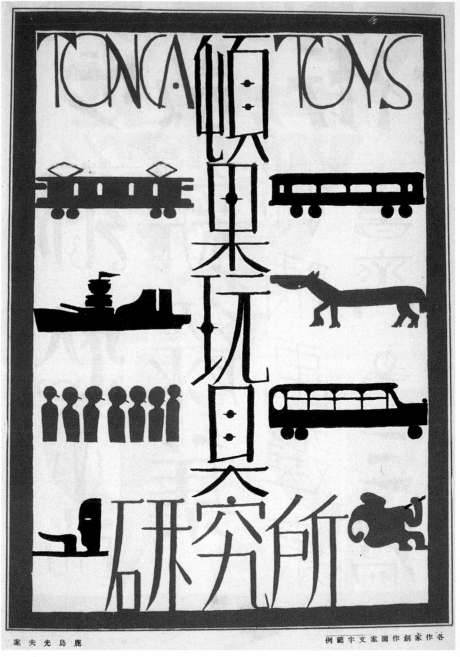

A sample of advertising lettering by Kashima Mitsuo for the Tonka Toys Research Center ca. 1929. Published in Hamada Masuji's 24-volume compedium: *The Complete Commercial Artist* (v.15, p54).

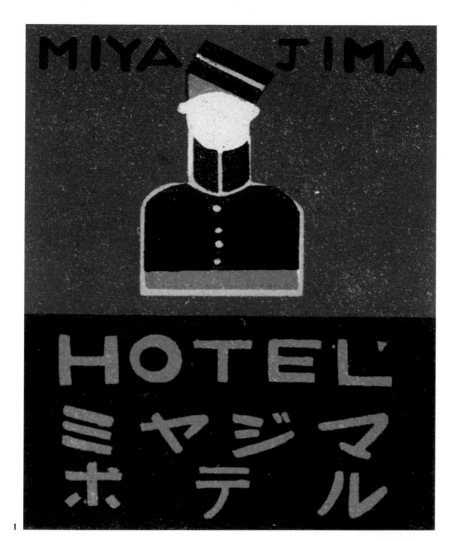

1 **"Miyajima Hotel"**
poster stamp
Artist: Izeki Tatsuo
Size: 5.2 x 4.2 cm
Complete Commercial Artist
(v. 18, p. 40)

2 **Photographer**
(illustration)
Artist: Unknown
Size: 21.5 x 15.5 cm
Note: From Shōgyō Bijutsu
Kōsei Genri (1931)

3 **Cafe Ginza Moderns**
(brochure)
Artist: Hara Mansuke
Size: 15.1 x 10.2 cm
Complete Commercial Artist
(v. 18, p. 56)

4 **"Children's Clothes"**
(illustration)
Artist: Unknown
Size: 21.5 x 15.5 cm
Note: From Shōgyō Bijutsu
Kōsei Genri (1931)

5 Swallow flying toward construction with ideograph for rain
Artist: Unknown
Size: 21.5 x 15.5 cm
Note: From Shōgyō Bijutsu Kōsei Genri

6 Negro entertainer
Artist: Tomita Morizō
Size: 21.5 x 15.5 cm
Note: From Shōgyō Bijutsu Kōsei Genri

7 Construction site with dirigible illustration
Artist: Unknown
Size: 17.5 x 13 cm
Note: From Shōgyō Bijutsu Kōsei Genri

8 "Summer Gift. Lucky Sale Days."
Artist: Unknown
Size: 21.5 x 15.5 cm
Note: From Shōgyō Bijutsu Kōsei Genri

9 Couple-facing-right illustration
Artist: Unknown
Size: 21.5 x 15.5 cm

10 Skier holding skis
Artist: Unknown
Size: 21.5 x 15.5 cm

11 "Hotel Green"
Artist: Yamana Ayao
Matchbox covers of various sizes

12 Travel poster stamp
Artist: Tsukamoto Gōji
Size: 6.1 x 4.4 cm
Complete Commercial Artist
(v. 18, p. 46)

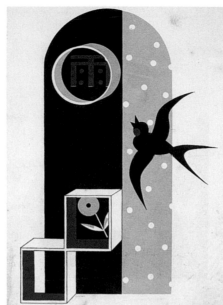

5

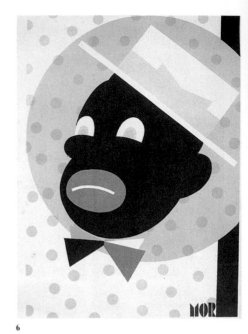

6

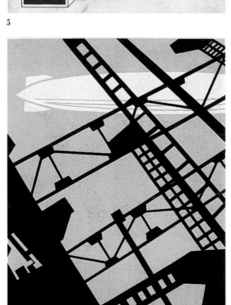

7

8

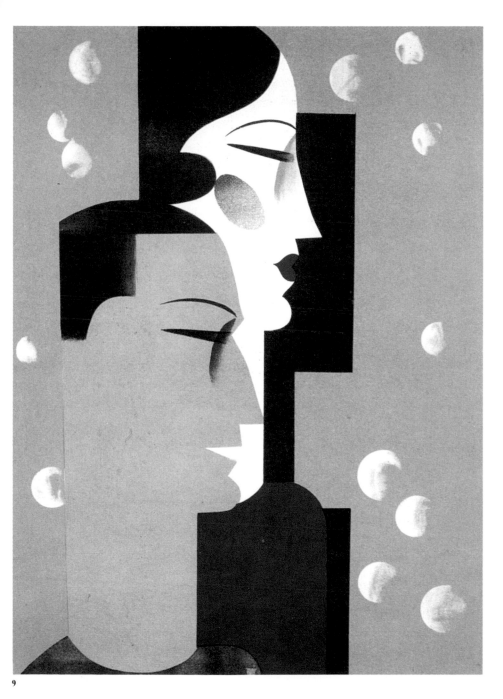

9

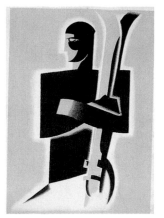

10

11

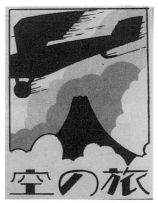

12

13 Musical instruments and
sheet music showcard
Advertiser: Tōyō Musical
Instrument Co., Ltd.
Artist: Kumamoto Yoshie
Size: 19.5 x 14 cm
Complete Commercial Artist
(v. 20, p. 53)

14 Children's sale day
pamphlet covers.
Artist: Tatsuta Ayaji
Size: 17.5 x 13.5 cm
Complete Commercial Artist
(v. 20, p. 43)

15 Children's clothing store
and toy exhibition
advertisements
Artist: Takashima Ichirō
Size: 21 x 14.6 cm
Complete Commercial Artist
(v. 20, p. 14)

16 "Barbershop," "Store for
Ladies" pamphlet covers
Artist: Tatsuta Ayaji
Size: 20.8 x 14.8 cm
Complete Commercial Artist
(v. 20, p. 46)

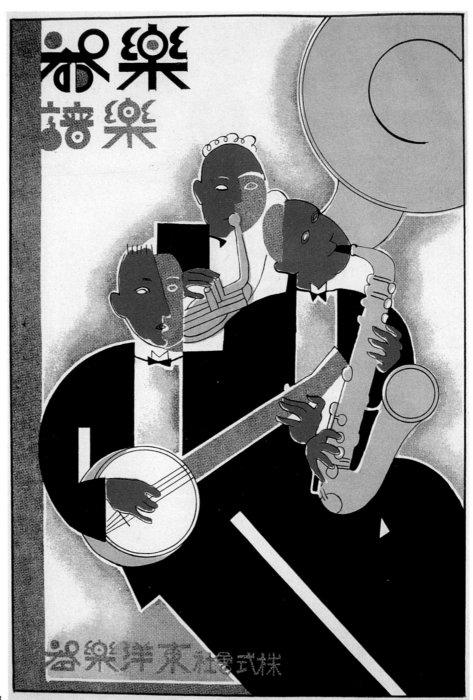

14

15

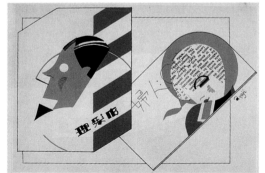

16

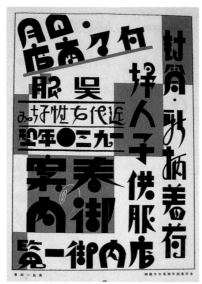

17

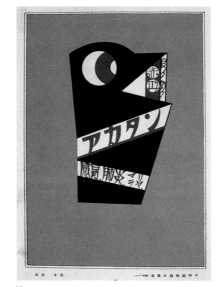

18

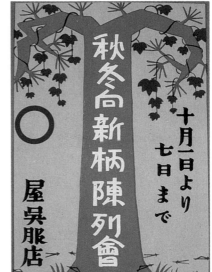

19

20

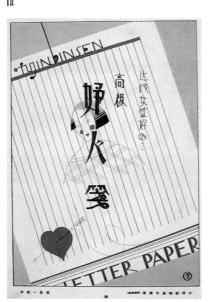

21

22

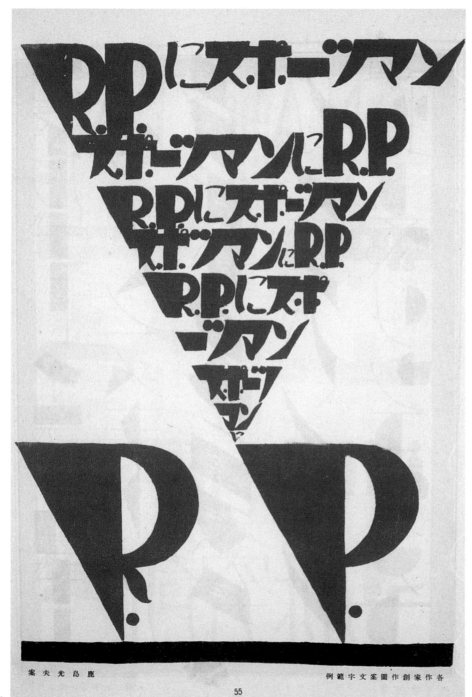

案夫光島鹿

55

17 Advertising lettering
Artist: Takashima Ichirō
Size: 21 x 15.3 cm
(v. 15, p. 62)

18 "Akatan works well for influenza, pneumonia, malaria" pamphlet cover
Artist: Tanaka Takeshi
Size: 21 x 14.8 cm
(v. 20, p. 47)

19 Kimono Store brochure cover
Artist: Suzuki Toshio
Size: 15.1 x 10.2 cm
(v. 18, p. 40)

20 Lettering for "Summer Gift" and special discount sale
Artist: Kotani Kiichi
Size: 21.2 x 15.5 cm
(v. 15, p. 37)

21 "Fujinbinsen Letter Paper"
Artist: "RO" (Takashima Ichirō)
Size: 21.3 x 15 cm
(v. 20, p. 49)

22 Advertising lettering
Artist: Koyama Keiichi
Size: 21.2 x 15.5 cm
(v. 15, p. 36)

23 Advertising lettering for sporting goods
Artist: Kashima Mitsuo
Size: 21.3 x 15.2 cm
Complete Commercial Artist
(v. 15, p. 55)

PERIODICAL

COVERS

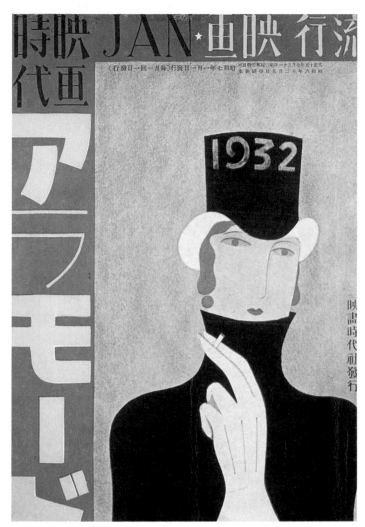

映画時代 JAN★映画流行
時代映画 アラモード
1932
映畫時代社發行

Cover designed by Kōno Takashi for the January 1932 issue of *Ala Mode*, a movie magazine.

T he design of Japanese periodical covers for special interest readerships underwent a transformation in the 1920s analogous to that observed in poster and book design. Transformation continued well into the 1930s. Of particular interest are the periodicals for advertising and photography, those for movie-goers and architects, and house

organs for the major department stores and cosmetic companies. One children's periodical, *Kodomo no kuni (Children's Land)*, merits mention for the Modernist influences shown both on its cover and in internal design. A number of its contributors were leading intellectuals and designers.

Three periodicals more in the mainstream of the Modernist movement, for which one cover each is shown here, are *Photo Times*, *Shin kenchiku (New Architecture)*, and the most important and longest-lived, Murota Kurazō's *Kōkoku-kai (Advertising World)*. The last was published from 1924 to 1941 and resumed publication in 1953 under the title *Idea*. All three of these periodicals relied heavily upon the use of photography throughout as well as for the covers. (The cover design of *Kōkoku-kai* tended to be more stylized, particularly in the early and mid-1930s.)

The periodicals of the left wing in literature and the arts leaned less toward Modernism than an international-left style. One example for which a poster is shown as representation of this style was *Senki (Fighting Flag)*, published from 1928 to 1931 usually with cover design by Yanase Masamu, Ōhtsuki Genji, or Matsuyama Fumio. The primary editors were Yamada Seizaburō (b. 1896) and Tsuboi Shigeji (1904–72). A similar periodical of the same genre and published by the same organization is *Napf* (an acronym derived from "Nippona Artista Proleta Federacio," the Esperanto name of the All Japan Federation of Proletarian Arts). *Napf*, edited by Iino Shōzō, was published from 1930 to 1931. The influence of the German and Soviet left dominated design, as there were close Berlin-Moscow-Tokyo

Back covers of issue number 3 and
issue number 4 of the short-lived
Belarto (1933).

ties in the decade spanning the 1920s and 1930s. But use of this style abruptly ended in the mid-1930s when the designers were jailed, went underground, or "converted" to a style approved by the growing police/military state. One short-lived periodical of the left art community noted for a nonsocialist realist design was *Nihongoban gaikoku bijutsu zasshi*, with the Esperanto subtitle *Belarto*, the title by which it is commonly referred to today. *Belarto*, published by Atelier Publishing Company for the founding editor, Suzuki Mitsuo, lasted for only four issues in 1933. The designer of the front covers is unknown. Shown here are the back cover of number 3, May 1933, as well as the back cover of number 4, June 1933, with an illustration by George Grosz.

For periodicals in general, so much cover art is unsigned that at this point one can only speculate as to possible designers, judging from the styles associated with individuals known to have been working in the various editorial groups. Only fragments exist of what might be called editorial archives of this period's periodicals. Many of the archives of the periodicals published in Tokyo were destroyed in the bombings and fires of World War II. From the archives of designers working in that period and doing periodical cover design researchers have been able to salvage only archival fragments. Major libraries did not, as a rule, collect designers' archives either in the interwar period or after World War II. What we know of that period and have been able to identify is due largely to a few assiduous collectors who scour flea markets and "spot sales" in Tokyo and the other larger cities.

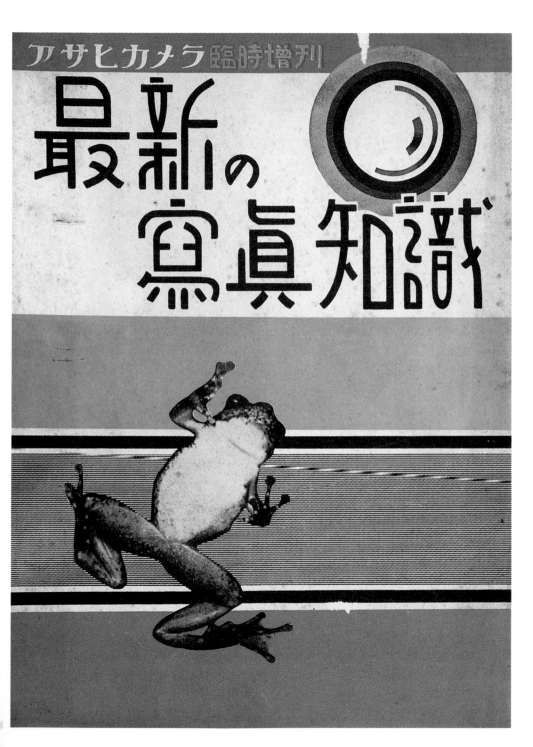

1 Saishin no shyashin chishiki
(November 1935)
The vanguard character of
the covers of *Asahi Camera*
(1926-1942, 1949-to date),
the name under which the
magazine is more commonly
known, was limited mainly
to the period from the early
to perhaps the late 1930s.
The periodical was pub-
lished in both Tokyo and
Osaka and was edited from
1934 to 1938 by Hoshino
Tatsuo. For the cover shown,
from an issue published for
the amateur as well as the
specialist, the designer is
unknown.
The periodical measures
26.3 by 19 cm.

2a

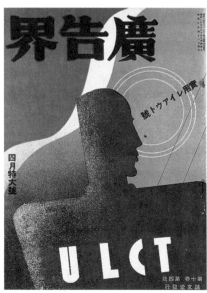

2b

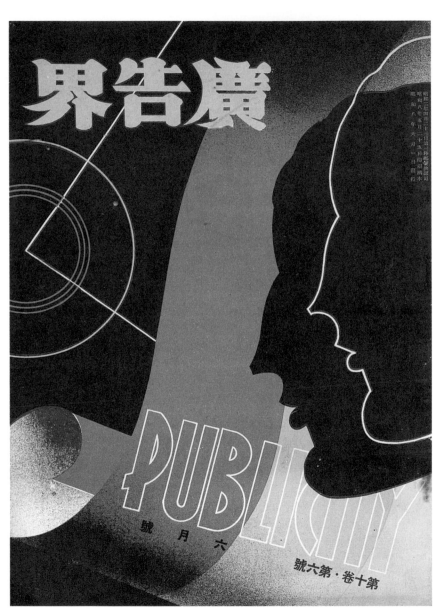

2c

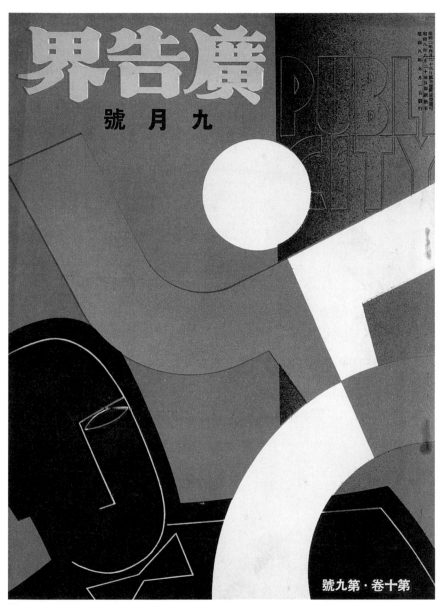

2d

2 Kōkoku-kai

(1926–41)
"Advertising World" was
the single most important
advertising periodical
bringing Modernist trends
to the attention of Japanese
designers throughout the
1920s and 1930s. Its found-
ing editor, Murota Kurazō,
was a major editorial influ-
ence in Japan in his time
as well being a graphic
designer of some note. (His
Shōten zuan sensyū portfo-
lio is described in the pre-
ceding chapter on Western
design guides.) Throughout
its history *Kōkoku-kai*
published contributions
from important critics and
designers.

The dates of the covers
shown here are:
a. February 1933
b. April 1933
c. June 1933
d. September 1933
*The periodical measures
25.6 by 19 cm.*

3a

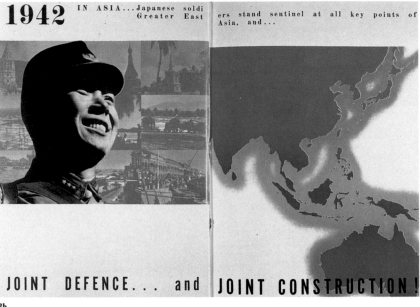

1942 IN ASIA...Japanese soldiers stand sentinel at all key points of Asia, and...
Greater East

JOINT DEFENCE... and JOINT CONSTRUCTION!

3b

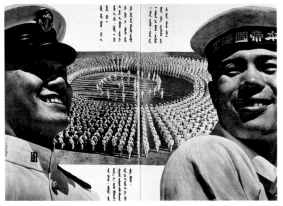

3c

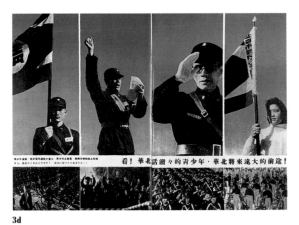

看！華北活潑々的青少年，華北將來遠大的前途！

3d

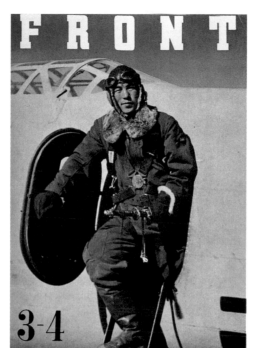

3e

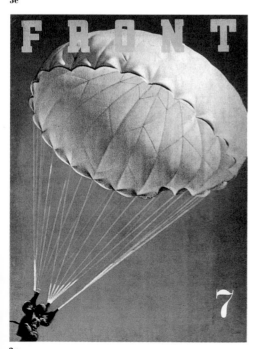

3g

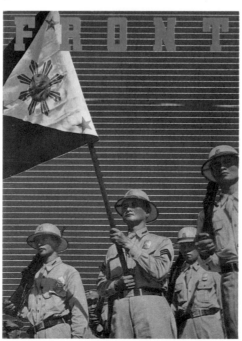

3h

3. Front

(1941-45)

A picture magazine published for the Japanese government by a private publisher, Tohosha, from 1941–45. The influence of the same-format Soviet picture magazine, *USSR in Construction* is apparent. Hara Hiromu was chief of the Tohosha art department and Kimura Ihee head of the photography department.

3a–3d. Shows double page spreads from selected issues of *Front*.

3e–3h. A selection of *Front* covers.

The periodical measures 41.5 by 29 cm.

4. Kenchiku Kigen

(October 1929–March 1930) Architecture Era, as the name translates, was published by Kōuseisha-shobō, Tokyo. The founding editor, Koike Shinji (1901–81), was a major design critic, and despite the short life (five issues) of this periodical it furthered the concept of the so-called International Style in architecture in Japan. Issue number 2, November 1929, was the Bauhaus issue, cover designed by Horiguchi Sutemi (1895-1984).
The periodical measures 30 by 22 cm.

5. Wakakusa

(1925–50)
The popular periodical *Young Grass* was founded by Fujimura Kōichi. Takehisa Yumeji contributed the two covers shown here.
a. January 1931
b. April 1931
The periodical measures 22.1 by 15 cm.

建築紀元　第一年第二號

NOV. 1929　　　　　構成計畫版一

4

5a

5b

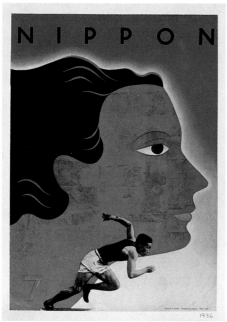

6a

6b

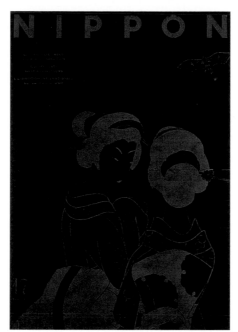

6d

6c

6 Nippon

(1934–44)

Natori Yōnosuke, on the revival of his studio, Nippon Kōbō, in 1934, reportedly asked the founder of Japanese art direction, Ōta Hideshige, who would be the best young designers to help found a new multilingual periodical titled *Nippon* to introduce Japanese culture into English-, French-, German-, and Spanish-speaking regions. Ōta responded: Kōno Takashi and Yamana Ayao. *Nippon*, more than any other national promotional periodical from the belligerent powers of the 1930s, attempted a total integration of design. From the first issue to the last, no Japanese ideographs appeared on the covers—not for image reasons but because *Nippon* provided a typographic statement for this team of designers who viewed existing Japanese typography as the greatest impediment to the development of a "new Japanese graphic design and style." Thus *Nippon* and the Hara Hiromu–designed *Front* (published 1941–44 as a war propaganda picture magazine) used Roman letter forms. Illustrations shown, all designed by Kōno Takashi, are:

a. No. 7, 1936
b. No. 15, 1938
c. No. 16, 1938
d. No. 17, 1938

The periodical measures 38.5 by 26.4 cm.

7a

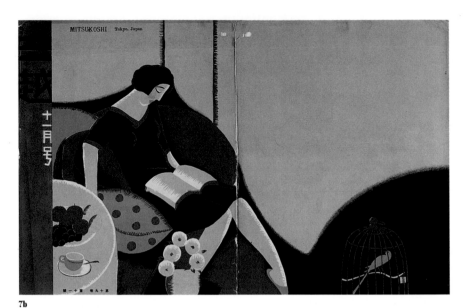

MITSUKOSHI Tokyo, Japan

7b

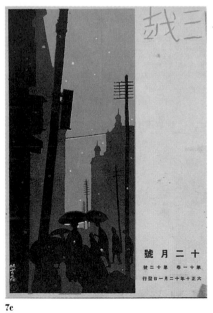

7c

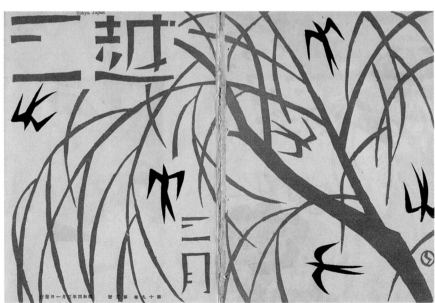

Tokyo, Japan

7d

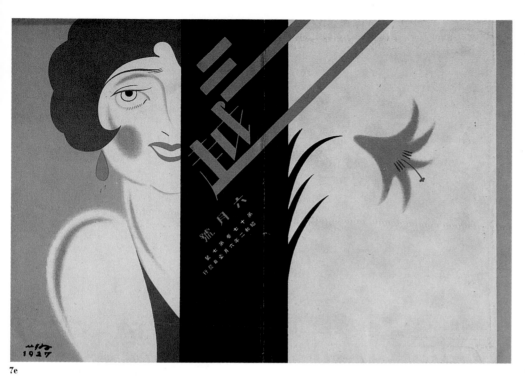

7e

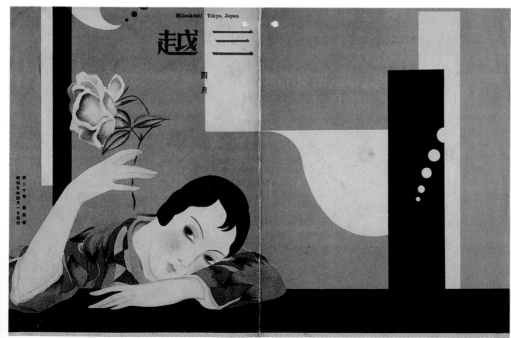

7 Mitsukoshi

(1908–33)

The Mitsukoshi Department Store published its primary public relations periodical for twenty-five years with few changes in periodicity and name. (The Osaka store published a similar publication, *Osaka Mitsukoshi*, from 1910 to 1932.) There was no monthly published from 1933 until 1949, when the Tokyo store initiated the house organ *Kinjita*. The cover artists for the Tokyo-based *Mitsukoshi* were mainly chosen by Mitsukoshi's art director, Sugiura Hisui, when he wasn't designing them himself. He contributed numerous covers including these six from the 1920s:

a. September 1928
b. November 1929
c. December 1920
d March 1929
e. June 1927
f. April 1926

The periodical measures 25.6 by 18.7 cm.

8. Shin Kenchiku

(1925 to the present, with an interruption during WW II)
Yoshioka Yasugorō was the editor-in-chief of *New Architecture* during the 1930s and used the monthly to advance discussion of modern architecture in Japan as well as modern architectural trends elsewhere. It was published in the 1930s by Shin Kenchiku-sha (Tokyo) and in those years measured 30.5 x 23 cm. The cover designer of the issues shown is unknown. The cover for volume 2, number 8 (August 1935)(8b) shows the house of Yamawaki Iwao and Michiko and was designed by Iwao, a Bauhaus student from 1930 to 1932. The cover of volume 12, number 10 (October 1936)(8a) shows an interior view of a corner of the Nonomiya Building designed by Tsuchiura Kameki, a student of Frank Lloyd Wright.

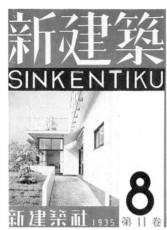

8a

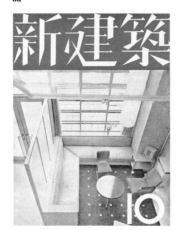

8b

9. Senki

(1928–31)
Fighting Flag was published by the Zen Nihon Musansha Geijutsu Renmei, also known by its Esperanto name, Nippona Artista Proleta Federacio (NAPF). The primary editors of *Senki* were Yamada Seizaburō (b. 1896) and Tsuboi Shigeji. The cover of the January 1930 issue shown here was designed by Yanase Masamu. *The periodical measures 22 x 14.7 cm.*

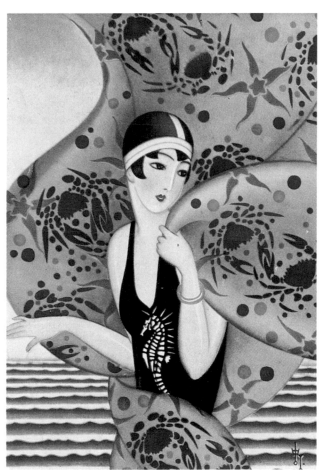

10. Nihon Shōnen
(1906–38)
A magazine for boys published in Tokyo by Jitsugyō-no-Nihon Sha and edited in this period by Nakajima Noriyuki. The cover of this March 1927 issue was designed by Takabatake Kashō (1888–1966).

11. Reijokai
(1922–44; 1946–50)
A magazine for senior high school girls published in Tokyo by Hōbun-kan. This mixed media illustration by Fukiya Kōji (1898–1979) was commissioned between 1922 and 1925.
The size of the journal at that time was 21.5 x 14.8 cm.

12. Shiseido Gurafu

(June 1930–September 1937)

This one of several house organs of Shiseido Cosmetic Company was edited by Shinohara Masao. This first issue shows the use of photomontage in its internal layout. The two-page spread features an article on Greta Garbo's eyes. The use of photography by Shiseido in its publications was to a great degree the work of Ibuka Akira and the designer Maeda Mitsugu. Ibuka was a member of the circle around *Photo Times*. Both men were primarily responsible for introducing photomontage to Shiseido's advertising program.

The periodical measures 19 by 13 cm.

13. Nippon Gekijo News

(Number 12, 1934)

Back cover advertisement for Kurabu Cream Toothpaste. The text boasts, among other things, "The fragrance is modern" and "Number One in the Toothpaste World."

This periodical measures 20.6 by 14.8 cm.

12

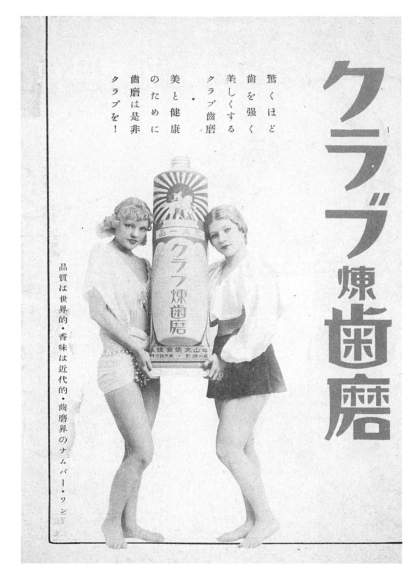

13

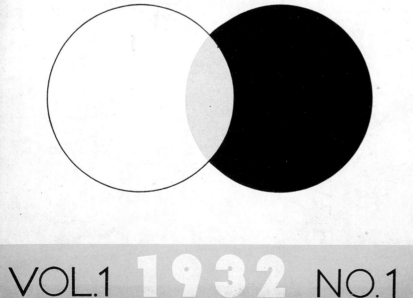

14a

14. Kōga

(1932–33)

Kōga was founded by Nakayama Iwata,
Nojima Yasuzō, Ina Nobuo, and Kimura Ihei.
Despite its brief life, *Koga* managed to
influence the new generation of Japanese
photographers profoundly as it was of major
importance in furthering the cause of the
New Photography in Japan. The covers were
designed by Hikita Saburō. Shown are
covers of:

a. Volume 1, number 1
b. Volume 2, number 7

The periodical measures 28.5 by 22 cm.

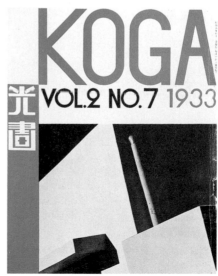

14b

SHOCHIKUZA NEWS

V · X

15a

SHOCHIKUA NEWS

V---XIII

15b

15. Shōchiku-za News
(1920–?)

The *Shōchiku-za News* was a monthly of the eponymous film company and distributor founded in 1895. The modernist trend is evident in the cover art of their magazine by the mid-1920s. One of the major early yet short-lived advertising agencies in Japan, Platon-sha, had responsibility for printing and publishing *Shōchiku-za News* at that time. Platon-sha was founded in Osaka and an office was established in Tokyo shortly after the Kantō earthquake of September 1923, but it was closed because of a business slowdown in 1928. In its brief existence it not only was a training ground for many designers but maintained more mature artists, who worked on the large accounts such as Shōchiku-za. Probably the best known of the artists was Yamana Ayao, who worked there from 1923 until its closure. It was there together with Yama Rokurō (1897-1982) that Yamana, along with other artists, created the distinctive European-Modernist covers for *Josei* (Woman), a fashion magazine, and presumably covers for *Shōchiku-za*. Only some of the covers shown here are signed, and none is signed by Yamana.

All measure 22 by 15.2 cm.

15c

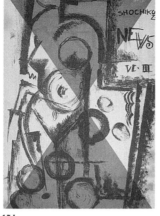

15d

15e

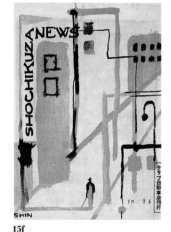

15f

15g

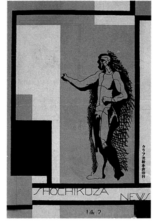

15h

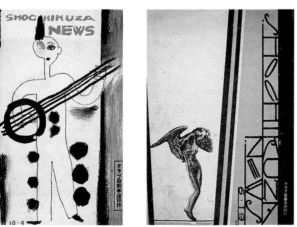

15i

15j

15k

a. *Artist:* Unknown
 Date: 1925, vol. 5, nr. 10

b. *Artist:* Unknown
 Date: 1925, vol. 5 nr. 13
*(Printed in Osaka by Nakayasu
Process Printing Company)*

c. *Artist:* Unknown
 Date: 1928, vol. 2, nr. 12 *(Back
cover advertisement for Katei soap)*

d. *Artist:* Unknown
 Date: 1926, vol. 6, nr. 33

e. *Artist:* Yamada Shinkichi
 Date: 1928, vol. 2, nr. 12

f. *Artist:* Yamada Shinkichi
 Date: 1928, vol. 10, nr. 26

g. *Artist:* Unknown
 Date: Issue "c" (above) *(Back
cover advertisement for Katei Soap)*

h. *Artist:* Yamada Shinkichi
 Date: 1930, vol. 14, nr. 2

i. *Artist:* Unknown
 Date: 19??, vol. 10, nr. 9

j. *Artist:* "Oka"
 Date: 1929, vol. 6, nr. 9
*(This discrepancy in numbering may
be explained by the fact that this
issue was published from the Kobe
office of Shōchiku-za, which likely
followed a different numbering.)*

k. *Artist:* Yamada Shinkichi
 Date: 1926, vol. 7, nr. 5
*(The cover shows a set design for
"Bluebeard's Castle.")*

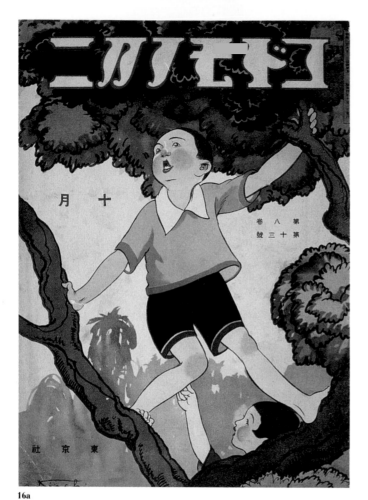

16a

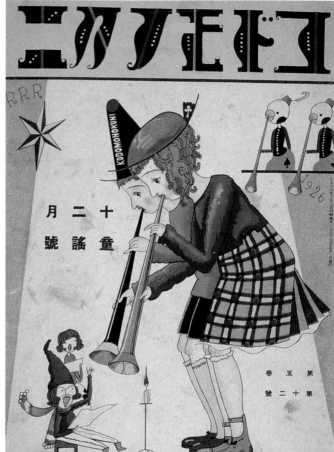

16b

16. Kodomo no kuni (Children's Land)

(1922–44)

This periodical for children had no equal in Japan or any other country in its time. Artwork of a decidedly Modernist tendency frequently appeared, usually the work of Takei Takeo (1894–1983), Fukazawa Shōzō, Hatsuyama Shigeru (1897–1973), or Murayama Tomoyoshi. The coarse, matte paper, the weight and thickness of cover stock, was absorbent in such a way that the opaque inks used gave the illustrations a brilliance setting it apart from the usual

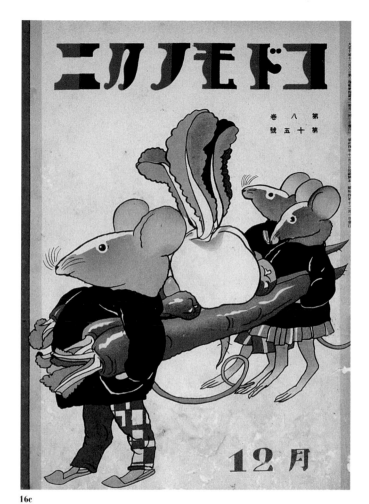

16c

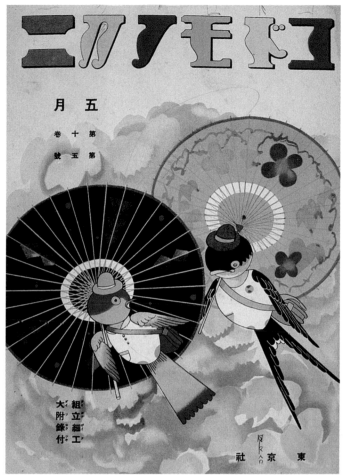

16d

children's periodical. The cover and interior illustrations were often
full-bleed, and double page illustrations were a regular feature.
Color was used throughout.

The magazine measured 25.7 by 18.5 cm.

The artists of the covers shown are:

a. Okamoto Keiichi (1888–1930), October 1929

b. Takei Kakeo (1894-1973)

c. Shimizu Yoshio (1891-1954)

d. Kawakami Shirō (1889–1984)

PAMPHLETS AND OTHER EPHEMERA

A substantial number of promotional pamphlets, labels, and other disposable, nonpackage items incorporated Western design idioms into the daily life of urbanized Japan in the 1920s and 1930s. Department stores and cosmetic companies were the most important producers, and they hired some of the most sophisticated Western-influenced art directors and designers of the era. Shiseido Cosmetic Company was a leader in this trend from its beginnings. Its decisions stimulated other firms to follow the Modernist trend.

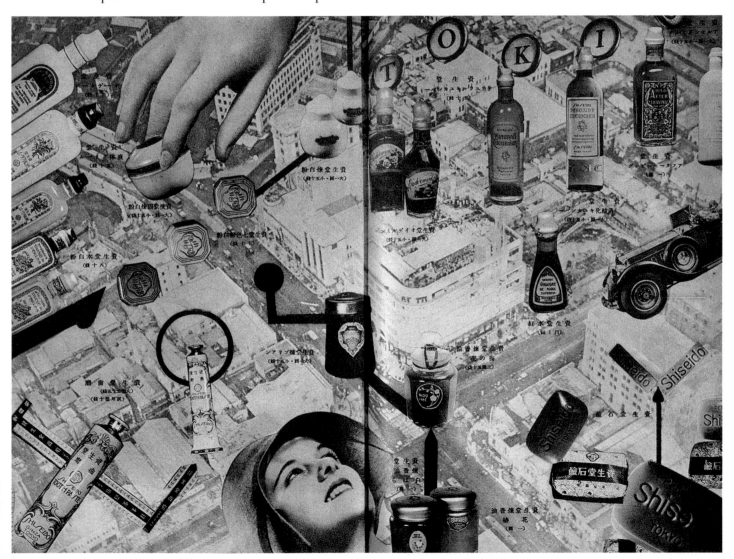

Double-page spread from Shiseido Cosmetic Co.'s promotional brochure *Home Calendar 1931*. Designers: Yamana Ayao, Maeda Mitsugu; photographer: Ibuka Akira.

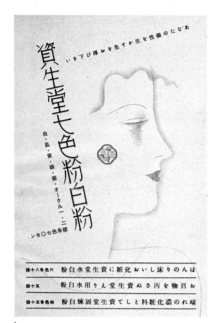

1a

1b

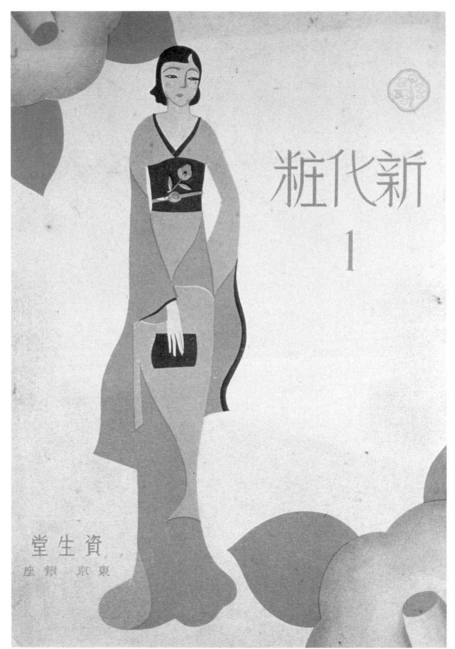

1c

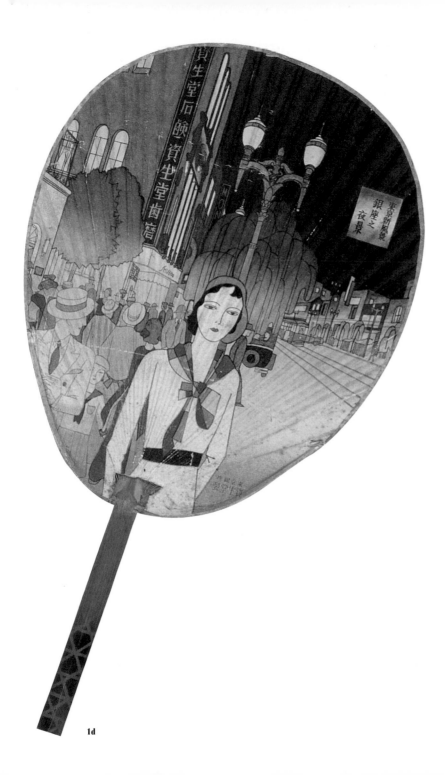

1d

1. **Shiseido's Home Calendar**, **1931**. This pamphlet was a one-time occurrence and contained, somewhat incongruously, two of the Modernist trends: the Yamana style and photomontage. The cover and the first page (**a.** and **b.**) show Yamana at his best. In 1932 Yamana designed the cover for another pamphlet offering new make-up products and titled **"New Make-up"** (**c.**). Another pamphlet produced in 1932 was a more extensive promotional work involving Yamana, Maeda, and Ibuka Akira. This pamphlet, titled *Yoso'oi (Adornment)*, like the *Home Calendar 1931*, also contained photomontage, full-bleed pages facing the attenuated line-drawn models of Yamana. The cover only (**g.**) is shown on the next page. In the same year Yamana designed what remains one of the most coveted of all Shiseido-Yamana promotional pieces, his **"Night Scene-Ginza"** fan (**d.**), the disk of which measures 21.3 by 17.8 cm. Yamana's Shiseido powder and cream designs for magazines and newspapers, shown on the preceding page as **a.** (powder, 1936?), and on the next page as **e.** (cream, 1937) and **f.** (cream, 1937), exhibit a continuation of the Modernist style well into the conservative-regime years when "Western influence" was increasingly frowned upon in official circles.

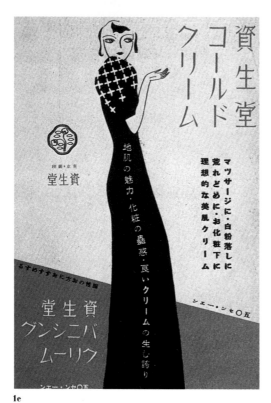

1e

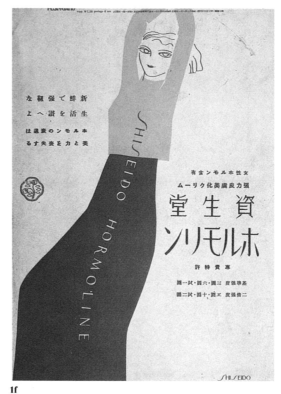

1f

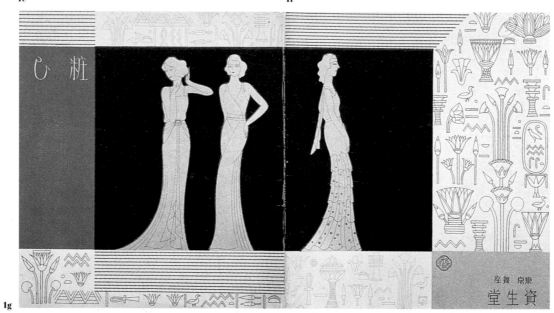

1g

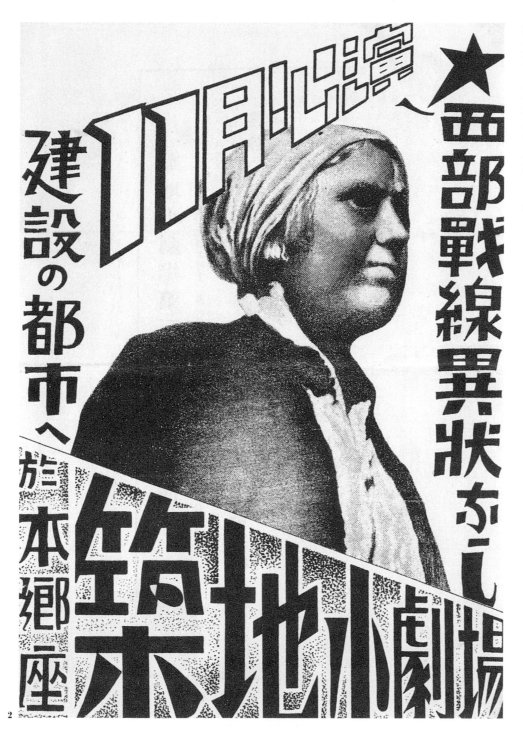

2. ***Theatre program*** for a performance of Erich Maria Remarque's *All Quiet on the Western Front* in November l929 in Tokyo. This performance by the avant-garde drama company Gekidan Tsukiji Shōgekijō was produced by Murayama Tomoyoshi. *This triple fold pamphlet measures 17.8 x 12.7 cm.*

A GUIDE TO MODERNIZATION OF

JAPANESE

TYPOGRAPHY

ラ マ ナ サ ア
リ ミ ニ シ イ
ル ム ヌ ス ウ
レ メ ネ セ エ
ロ モ ノ ソ オ

ワ ヤ ハ タ カ
ヰ ユ ヒ チ キ
ヴ ヨ フ ツ ク
ヱ ー ヘ テ ケ
ヲ ン ホ ト コ

One of the many efforts by Yajima Shūichi to give a Modernist look to the Japanese ideograph. A compendium of his designs was published in Tokyo in 1926.

J apanese designers of the 1920s and 1930s as well as today have dealt with the typographic problems of an extremely complex written language. There is one system used for written representation of phonetic pronunciation, one system that uses a mixture of forms derived from Chinese, and one system used mainly for words appropriated from languages other than Chinese. In the introduction to the compendium of typestyles from which most samples here are shown, Professor Takeda Goichi (1872-1938) of the Tokyo Imperial University calls for "... new letter forms to fit the modern commodities ... [that which has gone before] does not fit contemporary architectural and industrial needs." Takeda goes on to say that "beautiful typography is the most effective way of promoting the worth of a commodity." This compendium, *Zuan Moji Taikan (Typographic Handbook*, published by Shōbun-kan, Tokyo, 1926), was a noble effort for an ideographic language, as a consistent modification of stroke form is required. The compendium was the work of Yajima Shūichi, a young poster designer in the mid-1920s. In the professor's opinion, Yajima's work was the first codified effort to develop a significant sample of display type that was still true to the formal Japanese way of writing. Throughout the 1920s and 1930s there were repeated attempts by designers to come to grips with the static character of formal writing–efforts in shading, such as the work of Kurozumi Toyonosuke (1908–ca.1950), Obata Roppei, and others; and efforts to substantially alter the ideographic forms for titling in a particular design was attempted in the work of Yamana Ayao, Hara Hiromu, Takei Takeo, Kōno Takashi, and Okuyama Gihachirō (1907–81), among many others. The dictums of Professor Takeda have not diminished in importance. However, Japanese typographic experimentation today is only a continuation of Yajima's pioneering search.

アイウエオ
カキクケコ
サシスセソ
タチツテト
ナニヌネノ
ハヒフヘホ
マミムメモ
ヤイユエヨ
ラリルレロ
ワ井ウエヲ

いろは
にほへとち
りぬるをわ
かよたれそ
つねならむ
うゐのおく
やまけふこ
えてあさき
ゆめみしゑ
ひもせすん

カキクケコ
タチツテト
ハヒフヘホ
ヤユヨーン
ワ井ヴヱヲ
アイウヱオ
サシスセソ
ナニヌネノ
フミムメモ
ラリルレロ

A mid-1930s travel poster
by Kurozumi Toyonosuke
modifies ideographic forms
by shading,
and thus gives an illusion
of modernization.

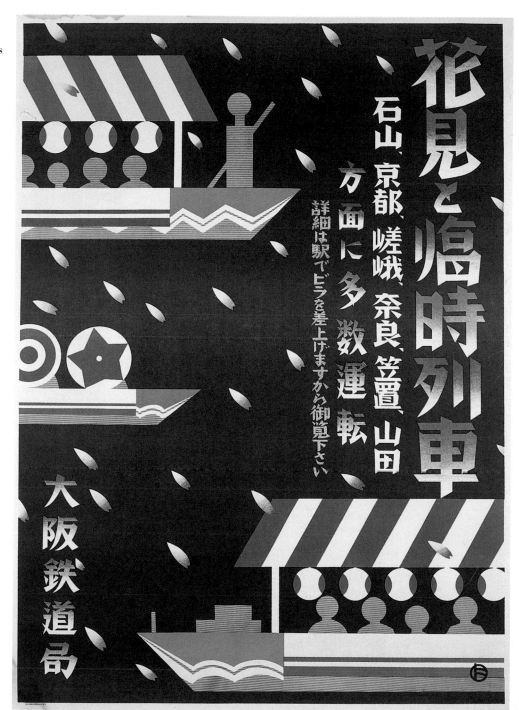

CREDITS

Artwork reproduced in this book has been provided, in the majority of cases, by the owners or custodians of the works. The publishers have tried to obtain permission to reproduce each illustration.

The sources of the artwork are listed alphabetically below, followed by the number of the page on which the artwork appears. Unless otherwise indicated, a page number refers to all of the artwork on that page.

Atelier Deska: 73 top right and bottom left, 97, 105

Calpis Food Industry Co., Ltd.: 52 left

Fraser, James: 9, 12-13, 24, 53 left, 59 bottom left and right, 62 left, 67, 69, 78 bottom right, 80, 102-103, 110 right, 112, 113, 114, 115, 125

Heller, Steven: 57, 123, 124, 126-128

Iizawa, Kōtarō: 111 right

Imatake, Shichirō: 28, 66 left

James, Caitlin: 17

Kawahata, Naomichi: 14, 98, 99, 100, 101, 104 top, 108, 111 left, 117, 121

Kōno, Isao: 79

Mitsukoshi Department Stores: 7, 58 top, 106, 107

Miyoshi, Hajime: 78 top left

Musashino Art University, Museum-Library: 51, 52 right, 53 right top and bottom, 55, 56, 58 bottom, 62 right, 66 right, 70, 72, 73 top left, 74 left, 75 left, 77, 78 bottom left

Nakahara, Yasuko: 71 left, 73 bottom right, 76, 85 right

Nihon no Kokoku Bijutsu: Meiji, Taisho, Showa. edited by Tokyo Art Directors' Club. (Tokyo: Bijutsu Shuppan-sha. 1967): 20, 22, 25, 27

Nishikawa, Hiroshi: 84

Shiseido: 31, 82, 83, 110 left, 118, 119, 120

Sugiura Estate: 54, 78 top right

Tobacco and Salt Museum: 60, 61

Tokushu Paper Mfg. Co., Ltd.: 71 right

University Museum of Kyoto University of Industrial Arts and Textile Fibers: 49, 70, 74 right

Waki, Tohō: 59 top left

Yamada, Takamasa: 50, 63

Yanase Estate: 64 right, 65, 68, 75 right

Yayoi Museum: 64 left, 85 left, 104 bottom left and right, 109, 132

SELECTED BIBLIOGRAPHY

In addition to the works cited in endnotes, the following exhibition catalogs and other works on the period, or works with sections touching on the period, are useful. These offer visual as well as textual introductions to particular aspects of graphic design in the period under discussion.

Kindai Nihon no Dezain Bunkashi 1868–1926, by Yatsuka Kayano (Tokyo: Firumu-āto-sha, 1992). A cultural history of the development of various forms and methods of advertising in Japan for the period indicated. A useful text but poorly illustrated in black and white. Text: Japanese.

Mai Dezain; Kōno Takashi: My Momentum (Tokyo: Rikuyō-sha, 1983). A brief autobiographical essay by Kōno Takashi with additional contributions by Inokuma G., Maki K., Tatehata K., Takamura H., Isoda H., Fukuda S., Tatsumura M. Text: Japanese and English.

Modan Tokyo Rapusodi; Rhapsody of Modern Tokyo, edited by Kaneko Ryūichi (Tokyo: Tokyo Metropolitan Museum of Photography, 1993). Catalog of an exhibition of a sample of Japanese photographers' work from the 1920s and 1930s. Text: Japanese and English.

Neji Kugi no Gaka, edited by The Yanase Masamu exhibition organizing committee (Tokyo: Musashino Art University, 1990). An exhibition catalog showing the range of Yanase's graphic art, including his paintings. Text: Japanese.

Nihon no Shashin 1930 Nendai Ten / Japanese Photography in the 1930s, edited by The Museum of Modern Art, Kamakura staff (Yokohama: 1988). Text: Japanese.

Nihon no Shūrurearisumu / Surrealism in Japan 1925–1945, edited by Nagoya City Art Museum staff (Nagoya: Nagoya-shi Bijutsukan, 1990). Text: Japanese.

Postā, edited by the staff of the Tobacco and Salt Museum (Tokyo: Tobacco and Salt Museum, 1987), volume 1. A catalog of posters advertising tobacco products exhibited by the Tobacco and Salt Museum. Text: Japanese.

Sen Kyūhyaku Nijyūnendai Nihon Ten, edited by Tokyo Metropolitan Art Museum (Tokyo: Asahi Shimbun-sha, 1988). Catalog of an exhibition of the graphic and poster arts of the 1920s in Japan. Text: Japanese.

Sono Bi to Ai to Kanashimi / Beauty, Love and Sadness, Yumeji and His Works, edited by Suzuki Hiromi (Tokyo: Yumeji Museum, 1990). Text: Japanese.

"Von der Venus der Erde zur Venus der Großstadt," by Ozaki Masato in *Japan und Europa 1543–1929; eine Ausstellung der "43. Berliner Festwochen" – Martin-Gropius-Bau-Berlin*, edited by Doris Croissant et al. (Berlin: Berliner Festspiele/Aragon, 1993), pp. 204–16; 551–52; 578–82. Ozaki's essay on European influences on Japanese painters and graphic artists is of specific interest because of his commentary on the culture of the Western city and its influence on the vanguard Japanese artists of the 1920s. Text: German.

Yayoi Bijutsukan. Taishū no Kokoro ni Ikita Sashie Gaka Tachi / Yayoi Museum: Illustrations in the Taisho-Showa Era, edited by Ōgawara Kōichi (Tokyo: Yayoi Museum, 1990). Text: Japanese.

Zuan no Henbō 1868–1945 / Design in Transition, 1868–1945. (Tokyo: National Museum of Modern Art, 1988). With contributions by Kaneko Kenji, Shiraishi Masami, Hida Toyojirō, and Hasebe Mitsuhiko. Text: Japanese and English.

ENDNOTES

1 See his essay in *Kirei—Plakate aus Japan 1978–1993*, Catherine Bürer, ed. (Zürich: Edition Stemmle for the Museum für Gestaltung Zürich, 1993), p. 23.

2 As reported by Takenchi Tsuguo, a professor at Kyoto University. Dr. Nakazawa, the first president of the university, charged Asai Chū (1856–1907) with the task of forming a teaching collection of posters when he accepted a professorship in 1900 at the soon-to-be-opened university. The architect Takeda Goichi (1872–1938) was also commissioned by the university to collect posters during his study trip in Europe from 1901 to 1904.

3 *The Graphic Spirit of Japan* (New York: Van Nostrand Reinhold, 1991).

4 Takashina Shūji, J. Thomas Rimer, with Gerald D. Bolas. *Paris in Japan: The Japanese Encounter with European Painting* (Tokyo and St. Louis: The Japan Foundation and Washington University, 1987).

5 Interview with Kawahata Naomichi, July 1993.

6 "Modernism's Golden Flower" by Ōyagi Tomoko in *The Artists and the Picture Book: The Twenties and Thirties*, edited by Shima Tayo et al. (Tokyo: JBBY, 1991); p. 17.

7 A special "MAVO" issue of *Art Vivant* (Tokyo) published by the Seibu Museum contained articles by Yurugi Yasuhiro, Mizusawa Tsutomu, Ozaki Masato, Omuka Toshiharu, and Matsuura Toshio. A great deal of the information for the articles in this issue number 33 (1989) was derived from Murayama's four-volume autobiography. The Berlin portion of Murayama's life is discussed in volume 2 of the autobiography *Engekiteki Jijoden* (Tokyo: Tōhō Shuppansha, 1971) and summarized on pages 18–28; 78–99 in this special issue of *Art Vivant*.

8 *Japon des Avant Gardes 1910–1970*, Françoise Bonnefoy et al. (Paris: Editions du Centre Pompidou, 1986); p. 56.

9 Publication was suspended with number 963.

10 Although private collectors and history-minded individuals in some of the larger companies have had their role in preserving Japan's graphic design history, it is the Tokyo Art Directors' Club that merits gratitude for an archeological effort of major proportions. In 1965 planning was set in motion for publication in 1968 of a record of Japan's advertising graphic history in commemoration of the TADC's fifteenth anniversary. This record in three volumes (v. 1, posters; v. 2, newspaper and magazine advertising; v. 3, packaging) shows, in color and black and white, the nation's commercial graphics history from 1868 to 1956. Publication of this work indirectly served the purpose of stimulating numerous collectors to rummage through attics and storerooms in search of yet more and different artifacts of Japan's advertising and packaging past. The overall title of the work is *Nihon no Kōkoku Bijutsu: Meiji, Taishō, Shōwa*, with volume 1 subtitled *Posters in Japan 1860–1956*.

11 *Kabushiki gaisha Mitsukoshi 85 (hachijūgo) nen no kiroku*, edited by Tanaka Koretake, Nakano Junich, Matsuzawa Megumi (Tokyo: Mitsukoshi, 1990).

12 Published by subscription by ARS (Arusu), a general publisher known for its book design in line with Modernist currents.

13 See *Nippon no Aaru Nūbo, Sugiura Hisui Ten*, edited by the staff of Asahi Shimbun-sha (Tokyo: Yūrakuchō Asahi Gallery and Asahi Shimbun-sha, 1988).

14 *Yamana Ayao Sakuhinshū / Works of Yamana Ayao*, edited by Nakamura Makoto (Tokyo: Seibundō-Shinkō / sha, 1981); pp. 8, 20.

15 *Josei* was the daring periodical for "the woman who would be Westernized." It continued the serialization of Tanizaki Junichiro's important novel of Tokyo popular culture of the late teens and early 1920s, *Chijin no Ai*, after government and public pressure forced the *Osaka Asahi* newspaper to suspend its serialization in June 1924. (The novel was translated and published in English as *Naomi* [New York: Knopf, 1985]).

16 *Shiseido-senden-shi*, edited by Yamamoto Takeo, Yabe Nobuhisa, et al. (Tokyo: Shiseido, 1979); vol.1.

17 *A Century of Japanese Photography*, edited by Japan Photographers Association with an introduction by John W. Dower (New York: Pantheon, 1980); p. 3. Also see *The Rise of Japanese Photography*, edited by the staff of the Tokyo Metropolitan Museum of Photography (Tokyo: TMMP, 1991); pp. 10–11.

18 Fukuhara Shinzō, like Nojima Yasuzō (1889–1967), was a leading exponent of the pictorialist movement and while at Columbia University in 1908 came under the influence of Alfred Stieglitz and his Gallery 291, but in the pre–Paul Strand era. Thus the impulses that ultimately came from Gallery 291 a few years later did not reach Japan through Fukuhara.

19 *Kikai to geijutsu tono kōryū / Tempo* (Tokyo: Iwanami-shoten, 1929).

20 Tokyo: Mokuseisha-shoin, 1932.

21 Of particular importance are the writings of Iizawa Kōtaro on Japanese photography. For this period in general: *Toshi no Shisen; Nihon no Shashin 1920–1930 Nendai* (Osaka: Sōgen-sha, 1989). For a discussion of the periodical *Kōga* see his *Shashin ni Kaere: Kōga no Jidai*. (Tokyo: Heibon-sha, 1988).

22 See Iwata Nakayama Shashin-shū in *Hikari no Dandizumu*, edited by Nakajima Tokuhiro et al. (Tokyo: Heibon-sha, 1987).

23 See "Photography and the Present Tense: The World of Nakaji Yasui" by Iizawa Kohtaro, *déja-vu*; nr. 12 (1993), pp. 8–10.

24 See *Kimura Ihei no Seiki*, edited by Tokyo Metropolitan Museum of Photography (Tokyo: Tokyo Metropolitan Culture Foundation and Tokyo Metropolitan Museum of Photography, 1992).

25 *Paris et la Seine* (Tokyo: Shashin-Geijutsu-sha, 1922); also *The Light with its Harmony* (Tokyo: Shashin-Geijutsu-sha, 1923).

26 *Kōga* was reprinted in 1990 by Fukkokuban Kōga Kankōkai in a three-volume boxed set but not as a facsimile.

27 See *Hara Hiromu Gurafikku Dezain no Genryū / The Works of Hiromu Hara*, by Kamekura Yūsaku, Tanaka Ikkō, et al. (Tokyo: Heibon-sha, 1985).

28 *Shiseido-Senden-Shi* edited by Yamamoto Takeo et al. (Tokyo: Shiseido, 1979); vol. 1, pp. 84–85.

29 See *Hōdōshashin no Seishun Jidai Natori Yōnosuke to Nakamatachi*, by Ishikawa Yasumasa (Tokyo: Kōdansha, 1991).

30 Interview with Kawahata Naomichi, 16 May 1994.

31 "The Origin of Osaka/Kobe Modernism," by Yamano Hidetsugu in *Shōwa no Modanizumu, Imatake Shichiro no Sekai Modernism in Japan: The World of Shichiro Imatake* (Osaka: Imatake and Associates, 1989).

32 Reprinted in facsimile in 1989/90 by Heibon-sha (Tokyo). The issues are boxed rather than bound.

33 See Tagawa Seiichi's monograph on *Front*, *Sensō no Gurafizumu/Kaisō no 'Front'* (Tokyo: Heibon-sha, 1988).

34 *Nihon no Posutā-shi / Posters Japan 1800s–1980s*, edited by Sumitomo Kazuko, Binshū Genichiro, Ōta Takayuki, et al. (Nagoya: Bank of Nagoya, 1989).

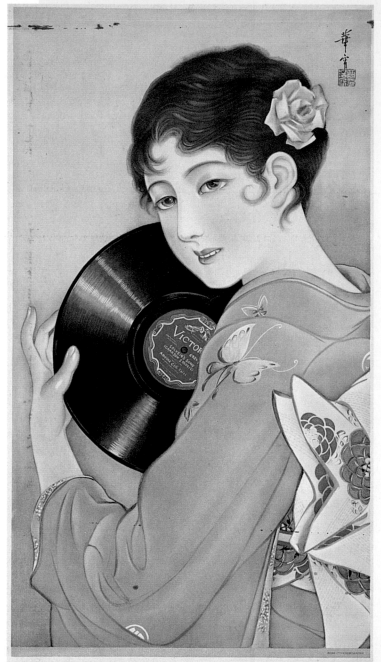